DESIGNING CORPORATE IDENTITY

IDENTITY

GRAPHIC DESIGN AS A BUSINESS STRATEGY

GLOUCESTER MASSACHUSETTS

ROCKPORT PUBLISHERS

PAT MATSON KNAPP

First published in the United States of America by
Rockport Publishers, Inc.
33 Commercial Street
Gloucester, Massachusetts 01930-5089
Telephone: (978) 282-9590
Facsimile: (978) 283-2742
www.rockpub.com

ISBN 1-56496-797-2

10 9 8 7 6 5 4 3 2 1

Design: Blackcoffee Design® Inc. • Boston

Printed in China.

For Ed, my partner and fellow sailor. I admire your Work. And for Emily, Chester, and Joseph, the three best kids on the planet.

CONTENTS

Introduction

"...Clarity in expressing the brand—whether it be for a manufactured product or for a business-to-business corporation—may be the final [business] frontier."

-Peter Lawrence, Corporate Design Foundation

At the starting gate of a new century, a volatile economy fueled by the Internet and new technology has created a business landscape that changes at warp speed.

Mergers and acquisitions in industries such as financial services, telecommunications, and energy have produced huge new corporations that must find ways to humanize themselves to appeal to local as well as global audiences. Companies rooted in traditional technologies are searching for inroads to the high-tech world. And at the same time, a new breed of Internet startups struggles to find footholds in the constantly shifting economic terrain.

For companies trying to survive and thrive in the New Economy, carving out strong and memorable identities is crucial. "Brand awareness" has become a corporate mantra, and many companies recognize design as among their most effective business tools. Executed well and applied consistently, strong corporate identities strengthen the bonds between businesses and their customers, and ultimately improve the bottom line.

"Design is an essential competitive element," notes Peter Lawrence, founder and chairman of the Corporate Design Foundation, established in 1985 to promote the integration of design and business. "We've covered price. Manufactured quality and technology are now essentially commodities, so they're no longer the determining factors in what to buy or which services company to use. Now, clarity in expressing the brand—whether it be for a manufactured product or for a business-to-business corporation—may be the final frontier."

Designing Corporate Identity follows 23 companies through recent identity launches, exploring the challenges, processes, and solutions behind them. Each of the 23 case studies—from large international corporations such as BP, TNT, and France Telecom to dotcom startups such as Plural and BuildNet—show how companies use design to connect with their audiences.

Their reasons for embarking on new identities are as diverse as the businesses themselves, but for purposes of this book are grouped into four general categories:

• Identity for Renewal (About Face)

For many businesses, staying fresh is the name of the game, and projecting a contemporary, updated image is essential to staying competitive. For these companies, new identities are often more evolutionary than revolutionary: They want customers to recognize an old friend, but be pleasantly surprised by a fresh new visual expression.

• Identity for Repositioning (New Horizons)

When a company redirects its business or expands into new products or services, it needs a way to signal the change to its marketplace. For these companies, a new identity must subtly play on the solidity and reliability of the original brand, but illuminate the new venture in a bold, visually arresting way.

• Identity to Signal Change (Sea Change)

Some companies outgrow their original missions or need to overcome erroneous impressions about who they are and what they do. Others need to change their name to reflect new business directions. Here, a new identity should help the company maintain any positive brand equities that already exist, but allow it to reintroduce itself to the marketplace.

• Identity for Growth (Fueling Growth)

Mergers and acquisitions, IPOs, and rollouts are now household words. But how do large corporations manage the changes brought by growth, consolidation, and other market changes? Many use new brand identities to stay connected with their local and global audiences.

But regardless of the reason for the change, effective corporate identities share some common elements, says Kris Larsen, managing director for Interbrand. "A strong brand should do four things: it should be relevant to customers; it should be credible (and by that I mean truthfully represent the brand); it should differentiate itself from the competition; and it should have the ability to stretch as the market stretches."

Effective brands are also a way for companies to forge an emotional bond with their audiences, says Ken Carbone, Carbone Smolan Agency (New York). "If you can touch their emotions in some way, the brand becomes a living, memorable thing."

ABOUT FACE IDENTITY FOR RENEWAL

For many businesses, staying fresh is essential to survival.

In an era when consumers are barraged with almost unlimited choices from a widening array of media, the ability to project a contemporary, up-to-date identity is crucial to staying competitive. The Internet dimension adds a new sense of urgency: The messages that businesses send must not only be fresh and articulate, but flexible enough to translate to the Web and other emerging media.

But tempering the demand for "new and exciting" is the need for consistency and familiarity. Many businesses recognize that while they need to freshen their identities, they also need to stay close to the old and familiar. For many of these companies, new identities are often more evolutionary than revolutionary: They want customers to recognize an old friend, but be pleasantly surprised by a fresh new visual expression.

Church's Chicken is an excellent example. In its highly competitive niche of the fast-food industry, Church's needed to update its identity to capture more market share. Its new identity is clean and sophisticated, but is based substantially on the star symbol it has used for many years.

Brown Shoe, the venerable St. Louis footwear company, hadn't changed its identity since the 1970s, when it had diversified into other areas of business. Now, solely devoted to shoes, the company wanted its new identity to reflect its role as a fashion leader, but also communicate its steadfastness and long history in shoemaking.

Also in this section: Other "renewal" identities from Office Pavilion San Diego; Sbemco, an Iowa manufacturer; and LeBoulanger, a bakery chain based in the San Francisco area.

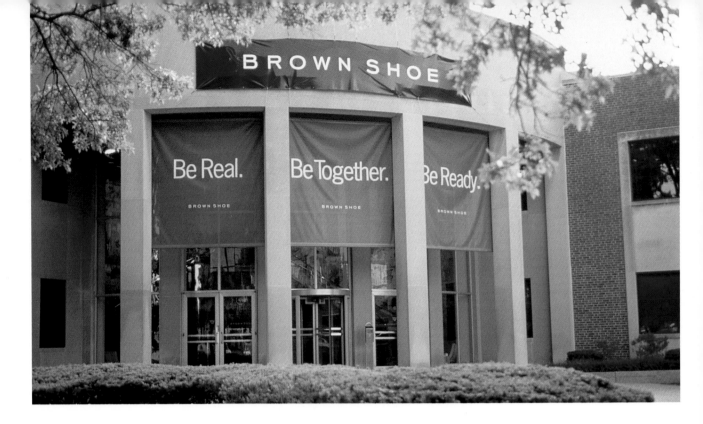

Brown Shoe Company

A venerable shoe company finds a fitting identity.

With more than forty popular shoe brands and 1,400 retail stores in its portfolio, Brown Shoe is one of the world's largest footwear companies. But its image as a stolid, conservative manufacturing operation in its hometown of St. Louis, Missouri—famous for "shoes and booze"—meant it got little respect as the fashion leader it had become.

Founded in 1878 as Bryan, Brown and Company, Brown Shoe had grown over the years into a manufacturer, wholesaler, and retailer of brands such as Naturalizer, Buster Brown, and LifeStride, as well as the designer/marketer of licensed footwear brands like Dr. Scholl's and Barbie. The company also owns more than 900 Famous Footwear and close to 500 Naturalizer shoe stores. Annual sales for the company reached $1.6 billion in 1999.

In the 1970s, the company had diversified into other businesses and changed its name to Brown Group. But by the late 1990s (under the leadership of new CEO Ron Fromm), Brown was again focused solely on shoes. Management recognized that the company name, and a corporate image that had become outdated and fragmented, should reflect the new focus. So in addition to reverting to its old name, Brown Shoe Company, management turned to Kiku Obata & Company (St. Louis) to polish its corporate image.

[above] *Signage was an important element of the program. Kiku Obata replaced the old, 1970s-era signage on Brown Shoe's corporate headquarters with temporary banners that promoted the new identity and taglines.*

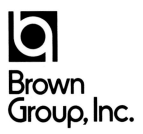

Brown Group, Inc.

BROWN SHOE

Client: Brown Shoe Company, St. Louis

Ron Fromm	chairman
Jo Jasper Dean	director, events marketing and special projects
Carol Wiley	manager, creative services, public relations

Design Team: Kiku Obata & Company, St. Louis

Kiku Obata	Scott Gericke
Amy Knopf	Joe Floresca
Jennifer Baldwin	and Carole Jerome

[above—left] (Before) In the 1970s, Brown Shoe had diversified into other non-shoe-related businesses. Its identity reflected the era and the diversification.

[above—right] Brown Shoe loved the visual pun referenced in the final solution. The "B" is formed by two overlapping heels, one in brown and one in black. Designers chose a modified version of Engraver's Gothic for the typeface and spaced the letters generously to give the logotype a stylish yet classic feel unique to Brown Shoe.

[left] To signal the community that change was afoot, Kiku Obata designed street banners in the same earthy color palette as the launch kit and brochures.

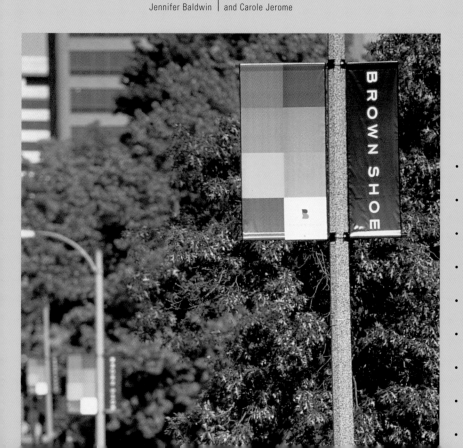

[above & opposite page—far right] *Early logo explorations focused on making the "B" its prominent feature. Designers also explored literal interpretations of shoes and other, more conceptual illustrative approaches. The team generated more than fifty initial logo sketches.*

Sizing Up the Brand

Kiku Obata started the process with an exhaustive research effort. First, the design team interviewed Brown Shoe employees across a wide range of positions and three management tiers. Then came reviews of existing market research, internal reports, and competitors' materials. Finally, the team evaluated Brown Shoe's marketing strengths and weaknesses.

The research was enlightening, not only for the design team, but for the company's employees. "I don't think many people in the company had ever seen a complete list of all the brands they were involved in," notes Kiku Obata. "It really helped us, and them, articulate who the Brown Shoe Company is."

Carol Wiley, Brown Shoe's manager of creative services, public relations, agrees. "It became very evident that we had not been focusing on the identity we were presenting to the outside world. People in different divisions were using different business cards, and some divisions had even been making up their own letterhead. This process became an opportunity for us to get a clear vision of Brown Shoe, and to pay attention to how we were presenting ourselves visually."

A New Self-Image

After four weeks of intensive research, Kiku Obata developed a presentation book and a series of boards to illustrate their findings. The team's strategic recommendations were dramatic: "Most of all, they needed to move away from the mindset of still being a manufacturer, and see themselves as what they are: a fashion company," notes Obata.

Brown Shoe's new identity needed to be "solid but smart," conveying the current, market-driven nature of the footwear business, but also communicating the trustworthiness and dependability of a 125-year-old company. It needed to position them well against competitors such as Nine West, but also convey that Brown Shoe is about fashion and comfort. With those attributes in mind, the Kiku Obata team presented three visual concepts as well as a series of identifiers, including a phrase ultimately adopted as its tagline, "The Leader in Footwear."

Although designers generated close to fifty variations of logos, explorations turned quickly toward treatment of the letter "B" as a visual pun. The final solution incorporates a stylized "B" shaped by two overlapping heels, one in black and one in brown. Beneath the symbol, Brown Shoe is presented in a clean, classic typeface based on Engraver's Gothic. Generous letter spacing and plenty of white space around the mark make it stylish and unique to Brown Shoe. "It's very simple, easy to read, and also fairly elegant," notes Obata. "It was intended to be solid but stylish, and something that has a sense of history behind it."

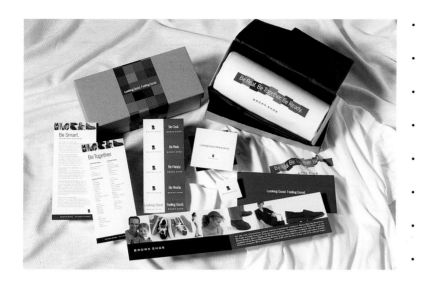

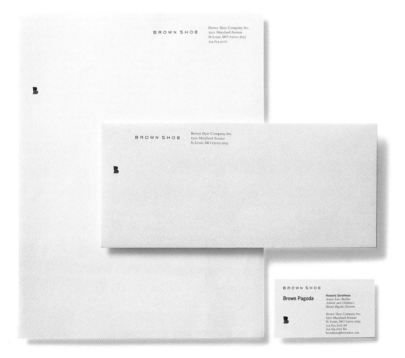

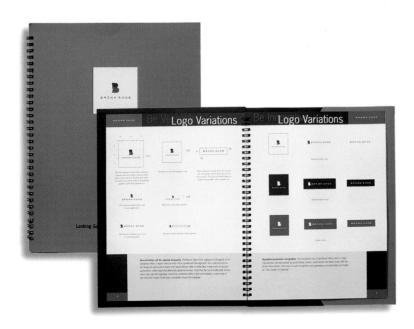

[top—left] *Brown Shoe needed a launch kit to introduce the new identity to its shareholders. Cleverly packaged in a shoebox, the kit included a t-shirt; footcare products; a "Be Smart" card summarizing the logic behind the name change; a "Be Together" card listing all of Brown Shoe's brands; and a series of "Be" stickers incorporating upbeat photo images.*

[middle & bottom] *Corporate collateral included stationery and business cards, as well as a graphic standards manual. To help ensure the identity is applied consistently throughout the company, the wirebound standards manual includes disks that provide electronic versions of the logo and document templates.*

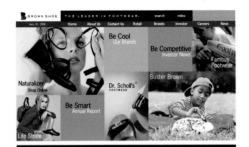

Putting the Best Foot Forward

Kiku Obata was also assigned to develop a launch kit for the annual shareholders' meeting, where the new name and identity were up for approval. To complement the logo and further the fashion-forward message, designers commissioned a series of upbeat, fashion-oriented photographs that are accompanied by taglines playing on the "B" theme: ("Be Real. Be Cool. Be Happy. Be Together. Be Ready."). The images form the core of the launch promotion, print ads, brochures, Web site design, and other materials developed around the new identity.

The photos, says Obata, add depth to the new image. "Corporate identity is not just about a logo. It's a whole look and feel, as well as a brand voice and attitude. All these elements must work together to communicate the brand image."

Obata's team applied the logo to stationery, signage, and a graphic standards manual that includes electronic versions of the logo, letterhead, fax and memo sheets, and other applications. They also created tradeshow booth and point-of-purchase concepts for the company's newly renamed children's' division, Buster Brown & Co.

Wiley says the new identity has helped the company sharpen its focus, both internally and externally: "It has given us a clear vision of who we are, and how to present ourselves to the world. It brands us as stylish, but timeless." ■

[above] *The Brown Shoe Web site borrows the look and feel of the new identity, promoting a lifestyle-based image and emphasizing the company's many popular brands.*

[right] *Promotional materials for a national footwear convention emphasized the kid-focused identity developed for the Buster Brown division. The "Bucket of Worms" kit, complete with gummy worms, was designed to entice recipients to the Buster Brown tradeshow booth.*

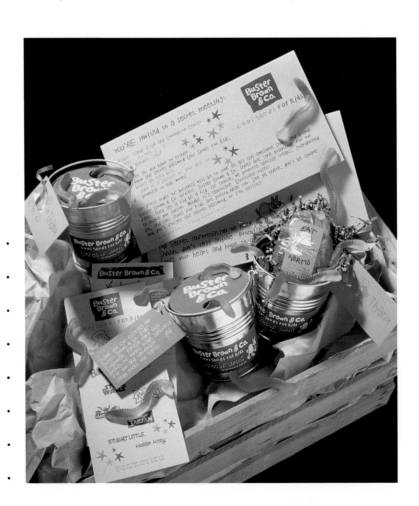

Brown Shoe Company

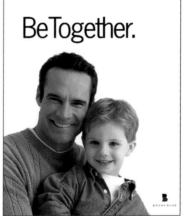

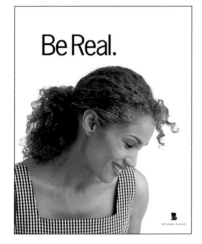

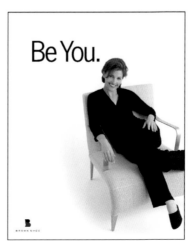

B

BROWN SHOE CO

[above] *The final three, more refined concepts included three distinct approaches: type only (top), with a symbol (middle), and with the "B" prominent (bottom).*

[above—left] *Kiku Obata also developed the logo for the newly renamed children's division, Buster Brown & Co. A separate graphic standards guide (second from top) addresses the colorful palette and whimsical images used for the kids' brands.*

[bottom—left] *Ads placed in footwear industry magazines position Brown Shoe as not just a footwear company, but a fashion and lifestyle leader.*

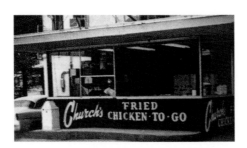

Church's Chicken | A fast-food chain returns to its roots to stay fresh in a competitive market.

Church's Chicken, started in 1952 as a family-owned restaurant, was one of the nation's first fast-food options. Established at the infancy of the national highway system, it helped pioneer the take-out window and the concept of "eating on the go." Today, the chain includes more than 1,000 restaurants, mostly in the South and Southeast.

[above] *Established in 1952, at the infancy of the national highway system, Church's Chicken was one of the nation's first fast-food options. Owners helped pioneer the take-out window.*

[opposite page—top] *(Before) The existing Church's Chicken logo, circa 1993, featured the Church's star and a palette of red, yellow, and teal.*

[opposite page—bottom] *To leverage the popularity of Church's Southern-style side dishes, Primo Angeli featured them prominently on packaging. Stylized illustrations of the sides are scattered all over the boxes and bags, which also include a blue-ribbon graphic with the tagline, "Chicken and biscuits made from scratch."*

Church's had updated its logo, signage, and store environments package in 1993, but its franchisees hadn't adopted the new identity consistently. Many restaurants in the chain never implemented the 1993 identity package, and as a result, there was a wide range of looks from restaurant to restaurant.

In 1999, Church's was capturing only eight percent of the market share in its category, behind KFC (at fifty-seven percent) and sister company Popeyes (at eleven percent). To change those numbers, Church's needed to create a fresh new identity that consistently conveyed its brand positioning, namely its made-from-scratch menu and traditional Southern hospitality. And the identity needed to be powerful enough to appeal to franchisees, who hold the purse strings at sixty percent of the chain's stores.

Church's called on Primo Angeli Inc. (San Francisco) to develop the new identity. "Our goal was to reach Church's existing demographic—middle-to lower-income families who need the convenience of prepared meals—in a warm, friendly way that invites them into the stores and emphasizes their unique product offerings," explains Richard Scheve, Primo Angeli Inc. project director.

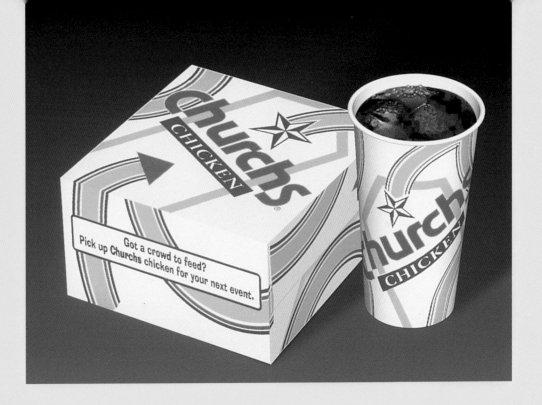

Client: Church's Chicken (an AFC Enterprises Company), Atlanta

Brad Haley	vice president of marketing
Jocelyn Blain	director of architecture and engineering
Deirdre Barrett-England	director of advertising and promotions

Design Team: Primo Angeli Inc., San Francisco

Jim Goodell	principal
Joe Bernard	vice president
Carlo Pagoda	creative director
Richard Scheve	project director
Ariel Villasol	senior designer
Peter Matsukawa	senior designer
Kelson Mau	senior designer
Vanessa Wyers	senior designer

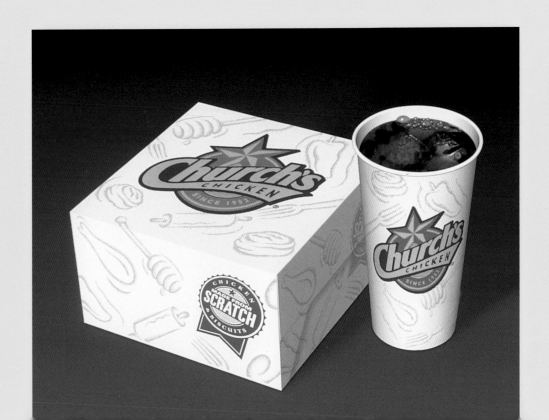

[above] *To help identify visual cues for expressing the brand personality, Primo Angeli developed "mood boards," photo collages representing possible design directions.*

Finding a Place in the Market

The Primo Angeli Inc. team launched the project by meeting with Church's executive team to establish marketing and design objectives, identify existing research, profile Church's target market, review advertising plans, and discuss opportunities and restrictions on the project. The team also reviewed design systems used by Church's primary competitors, focusing on how their packaging communicates image and price level. The team visited two key markets, Dallas and Church's hometown of Atlanta, to review retail interiors and exteriors of Church's franchise locations and its competitors.

Site visits were an eye-opener, says Scheve. "It was very enlightening for us to see how cultural aspects were ingrained in the lifestyles of Church's customers, and how important Church's side dishes were to the equation." Southern-style side dishes like biscuits, fried okra, and jalapenos are almost as popular as Church's fried chicken, and the design team quickly decided they should be featured prominently in the new identity.

Audits of competitors' store environments and packaging also helped the design team position Church's in the marketplace. Church's wanted to retain certain elements of its existing identity, primarily the star that refers to its Texas roots and the colors red and yellow. Church's was eager to discard the teal that had been added to its logo during the last identity update. Color selection needed to be planned around differentiating Church's from its competitors' packaging and signage.

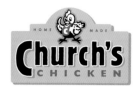

 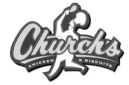

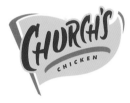 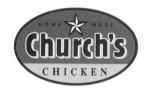 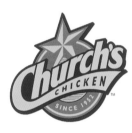

A Fresh Look

Based on their research, the Primo Angeli Inc. team developed and refined three alternative concepts and presented them to the Church's team on "mood boards." The concepts included "Texas Icons," which graphically represented the Alamo, road signs, chickens, and stars, particularly the Lone Star; "Today's Traditional Family," which evoked sit-down dinners, family values, and dinner for an economical price; and "Heritage," which symbolized Church's roots, including the highway, the 1950s, open roads, diners, and drive-through windows.

"This was our opportunity to identify visual cues, including color and typography, to further define the brand attributes and personality," explains Scheve. Using the concepts as a springboard, the team explored a wide range of new brand marks, from evolutionary designs that built on Church's star and color palette to more revolutionary concepts, including new characters and stylized chickens. They presented twenty logo concepts to the Church's executive team.

After narrowing the choices to three and asking the designers to refine them further, the Church's team ultimately chose a concept grounded in its existing star motif and its primary colors of red and yellow. But Primo Angeli Inc. created an entirely new brand personality by rendering the Church's name in a custom-drawn typeface that recalls team emblems from the golden age of baseball. They positioned the company name over a round emblem topped with a more contemporary version of Church's star and added dark blue to comple-

[left] *Logo explorations ranged from conservative to "out there." Some concepts were based on existing graphic elements such as the Church's star, while others broke new ground. Many were irreverent, such as the "chicken leg" identity shown (second from top, left).*

[above] *Church's narrowed the logo possibilities from twenty to three, then asked Primo Angeli to refine them and develop packaging concepts for each. Primo Angeli dubbed the final three concepts (top to bottom) "Alamo", "Diner", and "Baseball."*

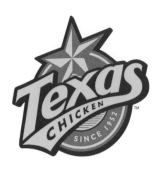

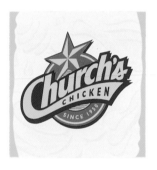

[above—top] *In China, where Church's operates a few stores, the word "church" translates to "cult." To avoid the negative connotations that might convey, they asked Primo Angeli to prepare an identical logo using the name "Texas Chicken."*

[above—middle & bottom] *Once Church's narrowed the logo choices, they asked Primo Angeli to test the logos on packaging concepts.*

ment the red and yellow. "It seems to harken back to a more simple day, but its clean edges and sophisticated lines also make it very contemporary and fresh," Scheve explains.

The companion package design incorporates the new logo, but also gives prominent placement to Church's popular side dishes. Bags and boxes feature illustrations of the side dishes as well as a blue ribbon with the tagline, "Chicken and biscuits made from scratch."

A New Environment

Once the logo and packaging designs were approved, the design team set to work applying the look and feel of the new brand identity to exterior signage. "They wanted something bright and inviting that screamed 'Get in here!'," Scheve notes. "And they wanted to place a lot of emphasis on the drive-through window, which is where they do a lot of their business."

The store's existing design was unique in that it integrated signage elements that framed the door, making an architectural statement. Church's wanted to maintain the look, but was also mindful of budgets, which did not cover major exterior renovations. So the designers looked for a cost-effective solution that would cover existing parapets and rooftop air conditioning units on most of the stores.

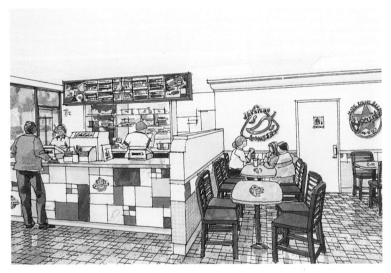

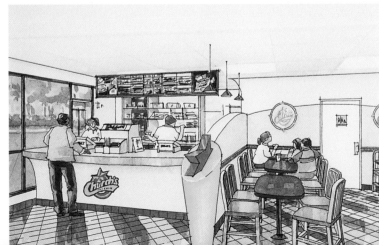

The solution is a new facade that transforms the building into a huge, architecturally integrated identity sign. A large, painted-metal canopy bearing the Church's logo sign is positioned over the entry doors, creating an effect reminiscent of a 1950s diner. Metal panels behind the canopy are painted to echo the curves in the logo. The canopy sign coordinates with the primary identity signage in the restaurant parking lot, and the drive-through is a marked by a huge, can't-miss-it arrow painted on the side of the building.

The new designs have been well received by Church's franchisees, and although store interiors weren't initially included in the project, Church's asked Primo Angeli Inc. to prepare schematic drawings to show how the exterior identity elements could be coordinated with interior decor.

The new brand identity and package designs are being used at Church's Chicken restaurants throughout the country, and initial customer reaction has been positive. Prototypes of the new environmental design are operating in two San Antonio restaurants. Franchisee adoption rates will be the ultimate measure of the interior program's success, says Scheve. "The greatest challenge will be to convince the franchisees that it's financially valid to make the changes. We feel confident the new design will produce quantifiable results." ■

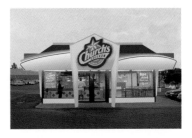

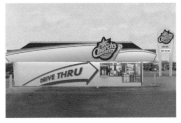

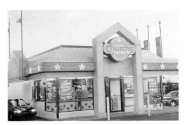

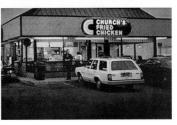

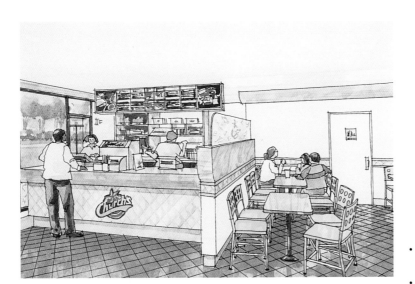

[above—top two] A new exterior graphics package turns the identity signage into an architectural statement. The painted-metal canopy draws attention to the entry doors and helps the design scream, "Get in here!" A huge arrow painted on the side of the building guides customers to the drive-through, where Church's does a significant amount of its business.

[above—bottom two] Many of Church's 600 franchisees had not implemented the 1993 identity (top), so 1970s-era designs were still scattered throughout the country (bottom).

[opposite page & left] Primo Angeli also developed schematic drawings showing how restaurant interiors could be coordinated with the identity graphics, packaging, and exterior signage.

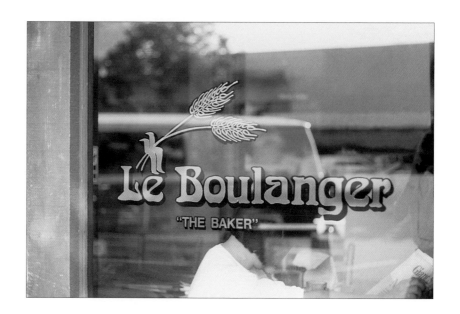

LeBoulanger

A Bay Area bakery chain keeps its identity fresh to encourage growth.

When LeBoulanger, a Sunnyvale, California-based chain of bakery cafes, began working with Tharp Did It in 1991, its owners had already found a recipe for business success. But they knew their small chain needed a strong visual identity to position it for future growth. So Tharp Did It (Los Gatos, California) created an award-winning logotype, packaging design, and signage solutions that helped LeBoulanger expand from seven to twenty-one stores by 2000.

[right] *(Before) The original LeBoulanger logotype and packaging, circa 1981, was designed by the owner. By 1991, the chain had grown to seven stores, but needed a strong visual identity to keep it growing.*

[opposite page] *(After) Seven years after Tharp created the first identity, LeBoulanger needed a fresh look. Tharp Did It designed a grid system inspired by Dutch painter Piet Mondrian and set text blocks and new pen-and-ink product illustrations within it. The new design also features "The Baker" more prominently.*

Seven years after Tharp created the identity, LeBoulanger's owners decided it needed updating, and turned to Tharp Did It again to help guide the evolution of the brand. "This identity had been phenomenally successful for us, and we didn't want to lose any of the equity we had established with it," notes Ray Montalvo, LeBoulanger's director of marketing and retail operations. "But to keep growing, we knew we needed to look fresh and modern to our customers."

A Smooth Transition

With new competitors arriving in the bakery cafe market, LeBoulanger needed a visual identity that would keep it ahead of the pack. While the bakery chain's executives were rethinking store interiors with an eye toward tweaking the existing color palette, the stores' menuboards also came under scrutiny. LeBoulanger asked Tharp Did It to redesign them, and soon realized that packaging and print communications should follow suit.

Client: LeBoulanger Bakery Cafes, Sunnyvale, California

Ray Montalvo | director of marketing and retail operations

Design Team: Tharp Did It, Los Gatos, California

Rick Tharp	principal, designer, writer, illustrator
Jana Heer	designer
Jean Mogannam	designer
Gina Kim-Mageras	designer
Nicole Coleman	designer
Cheryl Laton	designer
Kasumi Ito	designer
Ken Eklund	writer
Ray Montalvo	writer
Jim Barnes	writer
Don Weller	illustrator

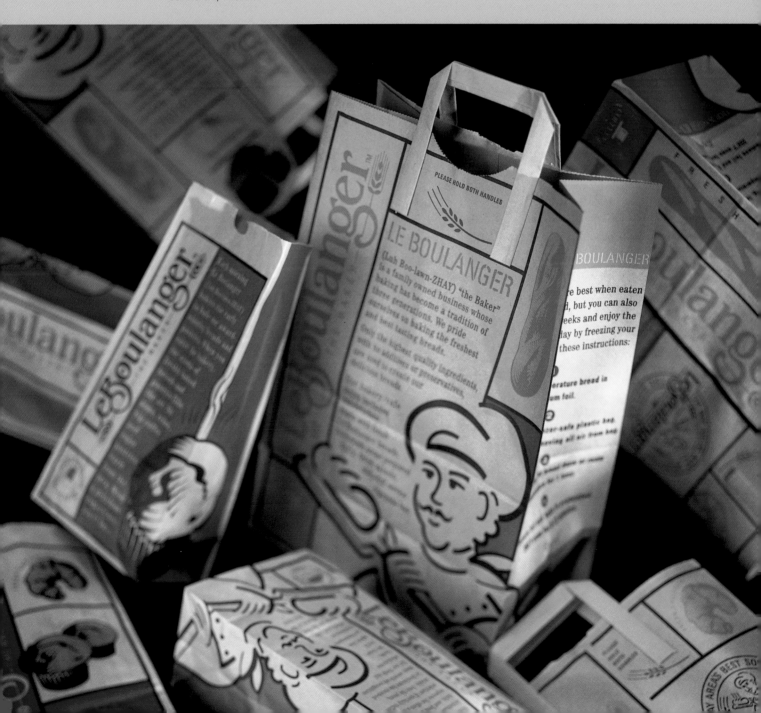

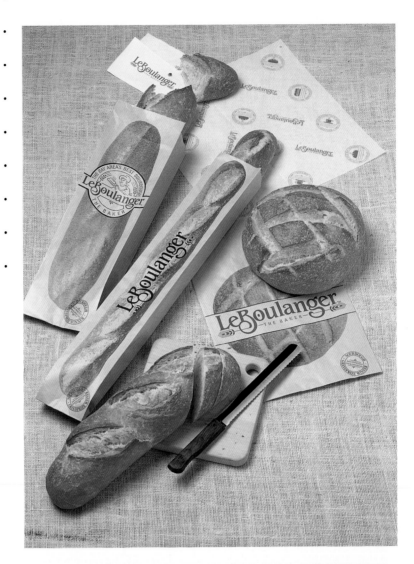

[above] *The original LeBoulanger packaging (top) used the owner's design. Tharp Did It's 1992 designs (above right) put more emphasis on the bread itself.*

[right] *For the 1992 identity, Tharp Did It designed custom-sized bread bags to fit LeBoulanger's varying products, as well as business cards and other marketing collateral. Mouth-watering mezzotint illustrations encouraged customers to buy.*

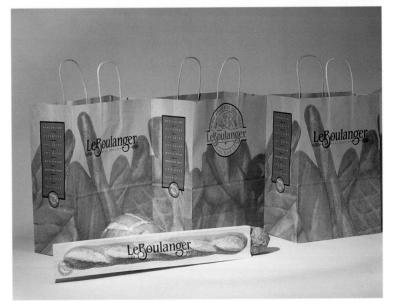

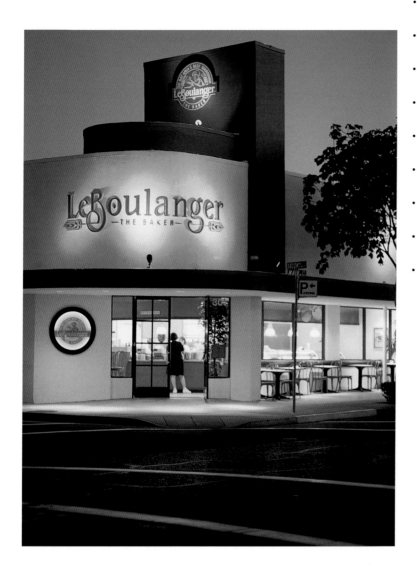

To keep costs down, LeBoulanger planned to roll out the new identity over a period of a few years, replacing packaging and promotional materials as supplies of the old ones ran out. So the new identity needed to blend harmoniously with the old one. Ideally, it would add a new dimension to LeBoulanger's brand message, but still complement the original graphic elements in place at the twenty-one stores.

"We also didn't want to alienate our existing customers with radical changes," notes Montalvo. "Sometimes when people see a new logo, they assume there's been a change in ownership, or even worse, that the product has changed in some way. We didn't want to send that message."

In With the Old (and New)

Tharp's team began by focusing on promotional, non-permanent elements of the program, such as shopping bags and other packaging, print ads, brochures, and take-out menus. LeBoulanger's existing hand-drawn emblem, which features the LeBoulanger "baker man" and the tagline "The Bay Area's Best Sourdough" in a custom typeface, was one element that needed to stay, says Rick Tharp, design firm principal. "So much equity had been gained over the

[above—left] *Suburban stores (top right) sported dimensional versions of the bread bag and loaf, while Tharp Did It designed a more subdued signage and lighting scheme for this store in historic Los Altos, California (top left).*

[above—right] *The LeBoulanger logotype, created in 1992, is still in use, but designers freshened its appeal by applying it on packaging vertically instead of horizontally.*

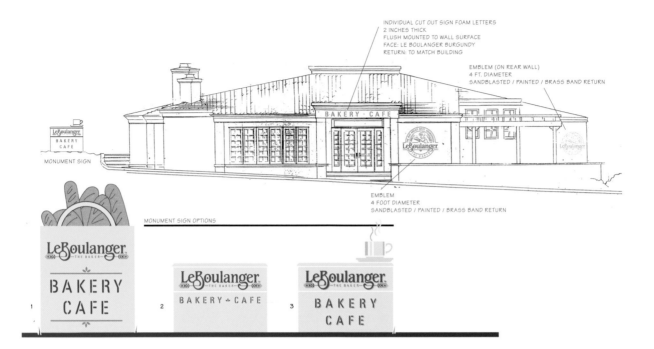

INDIVIDUAL CUT OUT SIGN FOAM LETTERS
2 INCHES THICK
FLUSH MOUNTED TO WALL SURFACE
FACE: LE BOULANGER BURGUNDY
RETURN: TO MATCH BUILDING

EMBLEM (ON REAR WALL)
4 FT. DIAMETER
SANDBLASTED / PAINTED / BRASS BAND RETURN

BAKERY · CAFE

MONUMENT SIGN

EMBLEM
4 FOOT DIAMETER
SANDBLASTED / PAINTED / BRASS BAND RETURN

MONUMENT SIGN OPTIONS

1 2 3

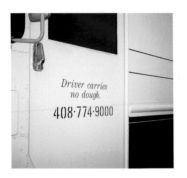

[above—top] *New stores, which LeBoulanger plans to add at the rate of two per year, will feature a new signage program. Tharp Did It designed emblem signs and three options for monument signage.*

[above—bottom] *Bread trucks were outfitted with simple applications of the identity. Tharp Did It's signature humor is evident in the "Driver carries no dough" message on the truck door.*

[right] *Takeout and catering menus show how the elements work in the grid. Because most of the chain's twenty-one stores would not be remodeled immediately, Tharp Did It kept the existing color palette of dark green and burgundy so that new packaging and print applications would match store interiors.*

years with [the] use of this emblem that there was no consideration of its redesign," says Tharp. "It has served LeBoulanger well over the years and customer recognition was important."

Tharp's design explorations focused on ways to increase LeBoulanger's iconic vocabulary and reenergize the familiar elements by presenting them in new ways. While concentrating on the messaging hierarchy for the store menuboards, the team devised a grid system inspired by the work of 20th Century Dutch painter Piet Mondrian. In the modular system, the LeBoulanger symbol is used vertically instead of horizontally, and the "baker man" character plays more prominently. Text messages and new pen-and-ink product illustrations are inserted into the grid in a playful yet defined way that breathes new life into the familiar graphic elements.

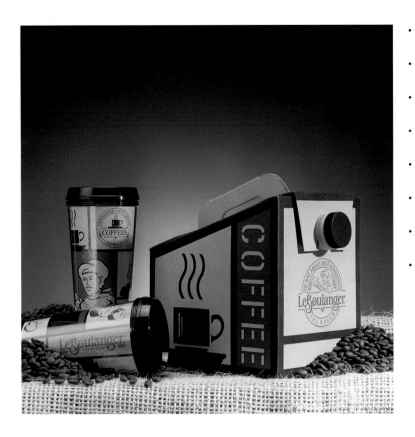

The modular grid system and the kit of illustrations also allow for easy application to LeBoulanger's Web site, company newsletter, print advertising, and point-of-sale materials.

Staying Power

LeBoulanger's new packaging system and menuboards have been installed at all of its stores, and new stores will feature coordinating interior decor. Some existing stores are being remodeled with new crown moldings, tiles, and other elements that coordinate with the identity system, says Montalvo. Meanwhile, LeBoulanger is following a "conservative" growth plan of two new stores per year.

If Tharp's first identity design is any indication of success, LeBoulanger will get plenty of mileage out of the updated system. In place a couple of years now, the system "hasn't gotten tired," says Montalvo. "Mondrian's grid is timeless, and I think our identity is also timeless."

By working with Tharp Did It, adds Montalvo, LeBoulanger has learned that paying close attention to the brand is crucial. "Over the years we've worked hard to maintain and refine our identity, and we pay just as close attention to it as large businesses like IBM and Nike. By holding it close and protecting it as much as possible, we make sure that customers recognize us and keep coming back." ■

[above] *When LeBoulanger added bagels to its offering, Tharp Did It designed in-store point-of-sale displays featuring an "Oy la la!" tagline and a slightly anthropomorphized bagel.*

[left] *Custom coffee packaging and coffee mugs follow the Mondrian-like grid.*

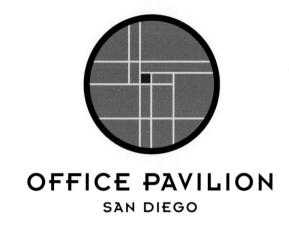

OFFICE PAVILION
SAN DIEGO

Office Pavilion San Diego | **A Herman Miller dealership's identity is inspired by the designs of Charles and Ray Eames.**

In 1994, when Vicky Carlson purchased an existing Herman Miller dealership in San Diego, she had her own very strong ideas about the way the business should be run and promoted. But for the first few years after the purchase, she focused on getting to know the market and avoided making drastic changes that might panic existing vendors and alienate customers.

[above] *The final brand mark for Office Pavilion San Diego (OSPD) connects visually with the Eames work as well as with the logos of Herman Miller and the national Office Pavilion network. The McCulley team chose the typeface Insignia for its rectangular, architectural letterforms.*

When the lease expired on her original building and she determined that a new, larger space was needed, it was Carlson's golden opportunity to make the statement she had always wanted to make. "Now was the time to tell everyone who we are and why we're different," says Carlson. She retained the design services of The McCulley Group (Solana Beach, California) to help make her vision a reality.

The McCulley Group's charge was to help Carlson create a strong visual identity within the San Diego design community, and in particular, to leverage the Herman Miller/Office Pavilion heritage and design aesthetic. McCulley was not only to create a corporate identity program, including a brand mark and supporting collateral, but was also commissioned to create the actual store environment from the floor up.

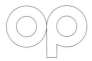 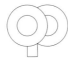 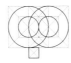 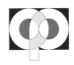

Client: Office Pavilion San Diego

Vicky Carlson | president/owner

Design Team: The McCulley Group, Solana Beach, California

John Riley McCulley | principal in charge
Ane Rocha | project manager, interiors
Julia Spengler | project manager, graphics
Jaime Laurella | interior designer
Gretchen Leary | graphic designer
Alan Robles | environmental graphic designer

[above] *Birth of a Symbol: The McCulley Group began logo explorations by focusing on the "O" and "P" letterforms, then placed them on a grid and experimented with their intersections. Influenced by the work of Charles and Ray Eames, particularly their famous Case Study House #8, they began to place more emphasis on the grid itself rather than the letterforms. They chose colors similar to the Eames house's DeStijl-influenced palette.*

Before the transition, the dealership had little or no corporate identity of its own, says John McCulley, principal in charge. Its graphic identity followed an older logo used nationally by other Office Pavilion stores, and its three-dimensional identity was disjointed and inconsistent. "Our opportunity was to build an entire corporate identity from the ground up that would mold the culture of the company and communicate its core values to employees, customers, and stakeholders at every point of contact," McCulley relates.

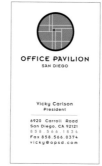

[above—left] *The front and back sides of the business card show how the new brand mark coexists with the existing Office Pavilion logo.*

[above—right] *OPSD's stationery features the brand mark and screened-back gridlines that reinforce the Eames influence.*

[right] *Designers encircled product icons in the same bold black circle as the brand mark.*

TABLES

OFFICE CHAIRS

SEATING

LIGHTING

CASEGOODS

SYSTEMS

ACCESSORIES

The Vision

Carlson envisioned a space that represented the Office Pavilion ideals of design, function, service, and attention to detail. Her dream store would be the ultimate working showroom, a model for the progressive workplace. "I wanted a space that's up-to-date but not trendy, beautiful but functional, and most of all, that says who we are and what differentiates us from the competition," Carlson explains. "It should be less about furniture than it is about our culture, how we work together as a team, and the things that motivate us."

Carlson had always been a fan of Herman Miller and of Charles and Ray Eames, the husband/wife team whose furniture designs are at least partially responsible for Herman Miller's heritage of great design. Adapting World War II research on materials and processes to furniture manufacturing, the Eames designed mass-produced pieces that were less expensive and more accessible to the general public.

As the McCulley team began design explorations for the graphic identity, they were inspired by the shapes, forms, rhythms, and colors in the Eames' work, particularly the front door and windows of the Eames' famous Case Study House #8. Early logo explorations focused on the letterforms "O" and "P" and the interplay between them when they were placed on a grid, says Julia Spengler, McCulley's project manager for graphics. But as the design evolved, "We began to take inspiration from the Eames house, which was built on a strict grid system. Eventually we placed more emphasis on the grid itself rather than the letterforms," says Spengler.

[left] *OPSD's main lobby features a white-on-white resin plaque of the brand mark. More gallery than retail store, the showroom was designed as a model for the progressive workspace.*

[middle] *A circular soffit over the reception desk (also a Herman Miller product) reinforces the circular motif of the brand mark. The photograph behind the desk is of Charles and Ray Eames.*

[right] *Circular references continue on the showroom floor. A system of frosted-Plexiglas panels (background) displays product graphics and can be easily snapped in and out of a ceiling- and floor-mounted cable system.*

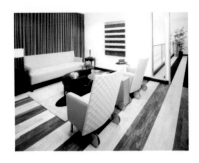

To define the symbol and provide a visual connection to the Office Pavilion and Herman Miller identities, the McCulley team encircled the grid and chose red and black as its primary colors. They added yellow for the gridlines and chose blue for the middle square, echoing the Case Study House's DeStijl-influenced color palette. Finally, they paired the new brand mark with the company name set in Insignia Regular, a typeface chosen for its rectangular, architectural letterforms.

[above—top] *The "president's lounge," with its distinctive striped-wood floors, is the ultimate combination of form and function. "The work environment tells you a lot about the company, and when customers step inside our door, they know we practice what we preach," says OPSD president/owner Vicky Carlson.*

[above—bottom] *Product display graphics echo the Herman Miller design aesthetic as well as the new OPSD identity.*

[right] *OPSD's new 8½x8½-inch (22x22 cm) marketing brochure focuses not on furniture but on the store's culture and business philosophies. "Customers were blown away by it," says John McCulley, design firm principal in charge.*

Bringing it to Life

To support the brand mark, McCulley Group designed a collateral system that includes business cards, stationery, a marketing folder, service "cut" sheets, and a marketing brochure that focuses more on emotions and philosophy than it does on product. "Vicky wanted to talk about her culture and how they work with people, not about selling product," says McCulley. "Customers were blown away by it."

As the design team was creating a two-dimensional brand, it was also designing the three-dimensional store environment and the OPSD's Web site (www.opsd.com). "The graphics and space planning both influenced each other," notes McCulley. "The forms in the showroom are very monolithic and geometric, and there are numerous references to the grid."

More of a gallery than a retail space, the showroom is architecturally understated so that the products can take center stage. Circle motifs recalling the new brand mark are everywhere, from suspended circular ceiling soffits that define space, to designs in the custom carpeting. To identify product lines and help guide visitors through the showroom, the McCulley team devised a graphics system of frosted-Plexiglas panels that can be snapped in and out of floor-and ceiling-mounted cable supports.

Making a Difference

Carlson is thrilled with the identity and with the results she's seen since the new showroom opened. Sales increased from $17 to $24 million in the partial year since the new identity was launched, and the showroom's close rate is ninety percent (ninety percent of those who visit the space actually purchase a product.)

"Design is important because it helps us tell our story," Carlson notes. "The work environment tells you a lot about the company, and when customers step inside our door, they know we practice what we preach." ■

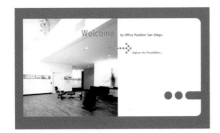

[left] *The OPSD Web site (www.opsd.com) uses the same graphic elements found in the brand mark and print collateral. To simulate the experience of "entering" the showroom, the McCulley Group created Flash animation that features the logo expanding so that its central square becomes the portal through which users enter the site.*

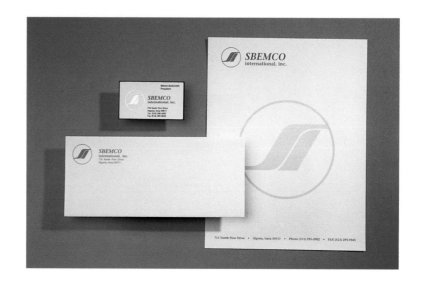

Sbemco International

A small-town manufacturer wows its market with a "nouveau industrial" identity.

Sbemco, an Algona, Iowa-based floor matting manufacturer, knew it didn't have the most glamorous product on the market. And its location in a small town two-and-a-half hours north of Des Moines also didn't garner it much respect from big-city clients.

[above] *(Before) Sbemco's old logo was plain and conservative, "industrial but not in a good way," says John Sayles, principal of Sayles Graphic Design. The company needed to make a bold statement and position itself as the leader in the safety floor matting market.*

[opposite page] *(After) Sayles created a bold new look for Sbemco that the client calls "funky industrial." The "S" symbol recalls a rolled-up mat. Sayles created a custom display font to lend the Sbemco name an "in-your-face" boldness. The fuschia-and-teal color palette was inspired by the patented backing that distinguishes Sbemco's product from its competitors'. Sayles added a unique twist, reproducing the backing pattern on the back of the letterhead.*

But Sbemco (pronounced with a silent "b") also knew it had a high quality product, and realized that building a strong brand identity in its market was the best way to grow its business.

"We needed a look," says Debra Wolfe, marketing spokesperson for the company. "We had been manufacturing our product for a master distributor, but we wanted to grow and market our own product. We needed to place ourselves in the market and make a bold statement."

Sbemco looked to Sayles Graphic Design (Des Moines) to develop a corporate identity and create marketing and trade show materials for the company.

"Sbemco wanted to attract Fortune 500 companies, and they needed to look more professional to do that," says John Sayles, principal of the design firm. Sbemco's existing identity was conservative and plain, "very industrial but not in a good way," he adds. The new identity needed to update Sbemco's visual identity and position it as a market leader.

Client: Sbemco International, Algona, Iowa

Brian Buscher | president
Debra Wolfe | marketing

Design Team: Sayles Graphic Design, Des Moines, Iowa

John Sayles | principal/art director and designer
Sheree Clark | principal/project manager
Wendy Lyons | copywriter

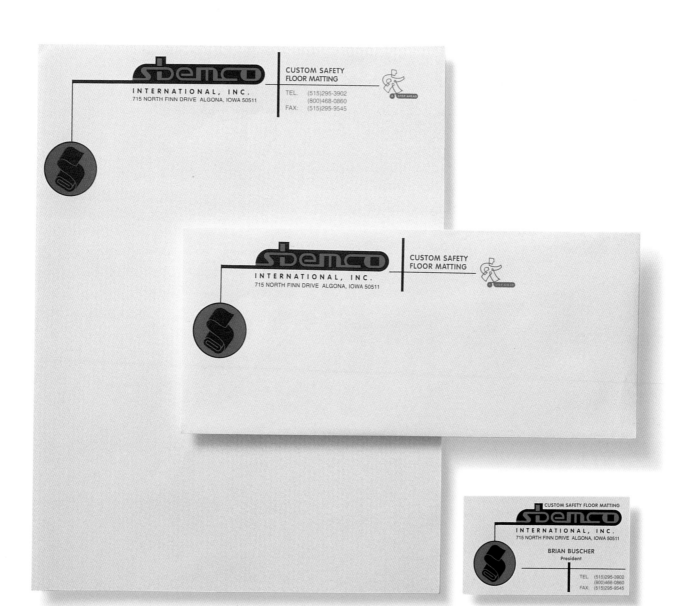

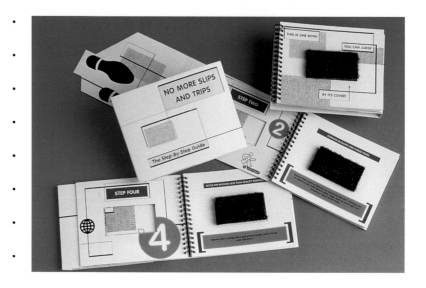

Making a Difference

Sbemco offers its safety floor matting to a wide range of clients, from risk managers at grocery store chains to architects and facilities managers for high-rise office buildings. Its primary differentiation from competitors is a patented backing that enhances the matting's safety performance.

Sbemco President Brian Buscher had already developed a product identity of sorts when he chose a distinctive palette of fuschia and teal for the backing. It seemed natural, says Sayles, to use the backing and its strong colors as the basis for the corporate identity and subsequent promotional materials.

Sayles strongly suggested changing the company name, since it is difficult to pronounce and doesn't directly refer to the company's core business. But Buscher felt there was enough equity in the Sbemco name to warrant its continued use. Again taking inspiration from the product, Sayles created a flowing "S" logo that recalls a rolled-up mat. He also created a custom display font that lends "in-your-face" impact to the company name, and borrowed the fuschia-and-teal backing palette for the corporate signature. The result is a bold, slightly retro aesthetic that Wolfe describes as "funky industrial."

Rolling Out the Identity

Sayles first applied the new logo to stationery, adding another unique twist based on the patented backing. The letterhead itself uses the "S" symbol in teal and black, with the company name in fuschia on a black background. Its reverse side mirrors the pattern on the backing, a subtle reinforcement of the product's distinction in the market.

Using the tagline, "A Step Ahead," Sayles continued to leverage the patented backing, with brochures, direct-mail pieces, and tradeshow promotions, all reinforcing the brand. Sbemco's promo-

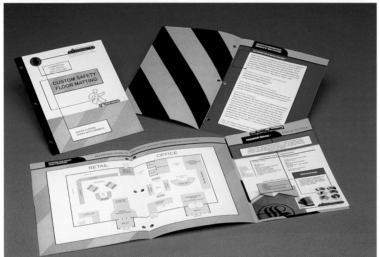

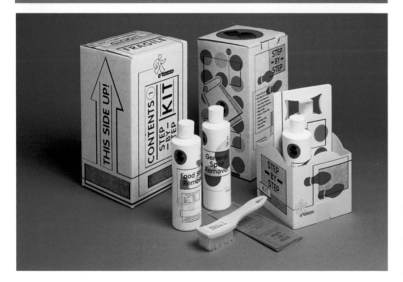

[top] *The Sbemco corporate profile includes three brochures housed in an offset-printed box in the familiar fuschia and teal, with the Sbemco monogram logo overprinted in gold. Each brochure covers a different facet of the company operation: leadership, technology, and product lines.*

[middle] *Reinforcing the company's focus on safety, Sayles designed a flexible product catalog that features a metal "brad" fastener for attaching inserts on product features.*

[bottom] *Sbemco's mat care product line continues the corporate color scheme and emphasis on the product's main selling feature.*

tional brochure, for example, is printed in fuschia and teal with die-cut pages that allow a piece of matting mounted on the inside back cover to be visible with each turn of the page. Sayles also designed packaging and labels for Sbemco's mat care products and designed its tradeshow booth to emphasize the product's selling points.

"It really made people sit up and take notice of us," says Wolfe of the new identity's launch at one of the industry's major tradeshows. "It gave us a real

presence in the marketplace and Sayles hit the nail on the head by using our product's main feature as a marketing tool." The identity has helped Sbemco establish itself as a major manufacturer and marketer of safety floor matting, and has encouraged the company to make plans to begin selling the product direct rather than through a distributor.

The results of having a professional visual identity have been so dramatic for Sbemco that it plans to update the brand again. Now a $10 million company, Sbemco plans to direct its marketing toward a higher-end market than it's currently pursuing. "We want to emphasize custom designs for buildings that need a high-profile, upscale look, and we want our identity to reflect that," says Wolfe. "We found out how effective a strong visual identity can be, and we want to continue that success." ∎

[right—top] *Trade ads and mailers make use of clever headlines and text, such as "The only thing black and blue in your store should be the floor mat," to emphasize Sbemco's safety features.*

[right—bottom] *Other promotional items included t-shirts (right) and translucent tradeshow bags (opposite page top).*

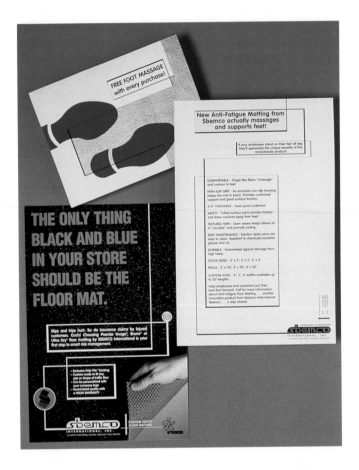

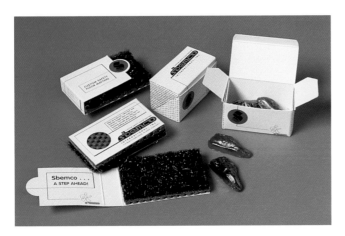

[left—second from top]
Tradeshow giveaways included a pair of chocolate shoes wrapped in pink and blue foil, yet another reinforcement of the company's "A Step Ahead" tagline and product features.

[left—middle] *Sbemco presents samples of their floor matting products in an elegant wooden box. The gift includes brass beverage coasters backed with the non-slip floor backing.*

[left—bottom] *Directed toward architects, this portable presentation kit showcases Sbemco's floor mats and outlines product features and benefits. The binder, again in Sbemco's signature fuschia and teal, is constructed of translucent corrugated plastic and holds product promotion folders and samples.*

NEW HORIZONS IDENTITY FOR REPOSITIONING

When a company redirects its business or expands into new products or services, it needs to signal the change to its marketplace. For these companies, a new identity must subtly play on the solidity and reliability of the original brand, but illuminate the new venture in a bold, visually arresting way.

Ameritrade Holding Corp., long known for its pioneering in the brokerage industry, continued to break new ground when it acquired two other e-brokerage firms in 1997. The identity created for the new online investment firm also broke new ground: Deliberately moving away from the conservative, "blue-chip" looks of its competitors, Ameritrade set itself apart by adopting a bold, abstract symbol and an eye-catching color palette.

Equity Marketing, a Los Angeles-based toy company that has created wildly popular promotional toys for Burger King and Arby's, wanted its new identity to signal its move into new business arenas, including a consumer toys division. To offset the stodginess of its name, Equity created a new logotype that is graphic, playful, and full of personality.

And when Headstrong (Fairfax, Virginia) and Plural (New York) abandoned their traditional businesses to plant their flags on the Internet landscape, they both needed bold new identities to announce their arrival. Headstrong crafted a young, hip identity based on a James Bond aesthetic, while Plural opted for a bold, simple solution that resonates with its clients.

Also in this section: Hungry Minds, a publishing company with roots in information technology, moves beyond its original mission into e-learning and other media; and Tabacalera SA, perhaps the world's oldest cigar maker, crafts an identity designed to capture the American market.

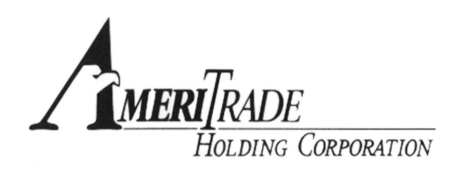

Ameritrade

An online brokerage firm breaks new ground, again, with its corporate identity.

Ameritrade Holding Corp. might best be known for breaking new ground. Established in 1971, as a local investment-banking firm, it was one of the first companies to offer discount brokerage following the deregulation of its industry in 1975. In 1988, it was the first to offer automated touch-tone telephone trading, and in 1995, it pioneered the use of portable communication devices for trading. Ameritrade was also one of the first brokerages to offer online investing and, more recently, is known for its break-through $8-per-trade pricing on the Web.

[above] *(Before) Ameritrade's existing logo was typical of its competitors in the financial services industry. Its new identity needed to break away from the look of others in this category.*

[opposite page—bottom] *In the refinement phase, Interbrand designers honed in on the cursor symbol as a simplified representation of Ameritrade users' point of contact with its service. The "energy bars" physically represent what happens when users click on it, and more metaphorically, rays of inspiration or power. The arrow, tilted at about 45 degrees also recalls Ameritrade's "A" or a pyramid or mountain.*

When the Omaha, Nebraska-based firm acquired two other e-brokerage firms in 1997, and combined their services to create the Ameritrade brand, it needed to establish a high profile in the marketplace. Ameritrade needed a strong, but flexible, brand identity that would work equally well in print, television, and Web applications, and one that could grow with the company as its online business took off.

The company chose Interbrand (New York) to build the strong visual foundation it needed to wow the market. "Their goal was to create a highly visible brand and they were prepared to put advertising dollars behind it," notes Kris Larsen, managing director of Interbrand's Chicago office, which handled the project.

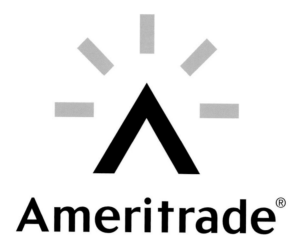

 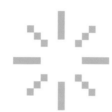 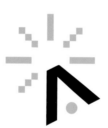

Client: Ameritrade Holding Corp., Omaha, Nebraska

| Anne L. Nelson | vice president of marketing and product development |
| Tim Smith | director of advertising and branding |

Design Team: Interbrand, Chicago

Kris Larsen	executive strategic director
Ronald Bielski	director, brand strategy
Stephen Bass	creative director
Derek O'Connor	creative director
Kyle Boynton	design director
Andrew Lincoln	consultant
Constanza Pardo	consultant
Troy Lindley	designer

[above—top] *The new mark and logotype were designed to be used together initially, but designers hope the mark will eventually stand on its own. The simple, geometric symbol works well in a wide range of sizes, from small Web banners to television and direct mail.*

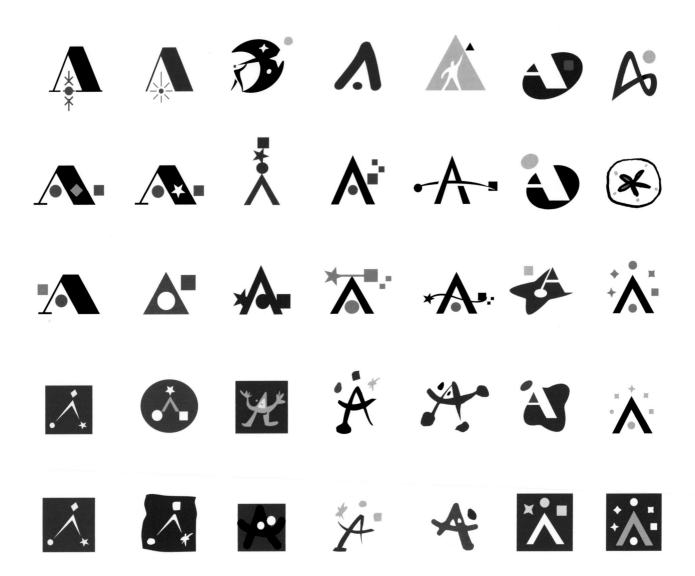

Distilling the Message

[above] *Early stages of the design exploration focused on abstract symbols that would represent the "A" in Ameritrade, the Internet connection, or Ameritrade's core values.*

As Interbrand interviewed management and analyzed Ameritrade's business strategies, the company's brand message became very clear, says Larsen. Ameritrade had decided to differentiate itself based on value, and its $8-per-trade pricing on the Internet was very successful in setting it apart from competitors.

But value was not Ameritrade's only brand proposition. The company also wanted to emphasize the ease of use offered by its online services, as well as the speed at which investors could access their accounts. Value, speed, and ease of use became the "brand positioning pillars" the Interbrand team used to build the identity. Supporting these pillars, explains Larsen, were Ameritrade's passionate convictions about the power of the individual and the value of time. Ameritrade's messaging needed to focus on creating value by exceeding customer expectations, increasing speed by respecting customers' time, and optimizing customers' experiences by respecting their individual needs.

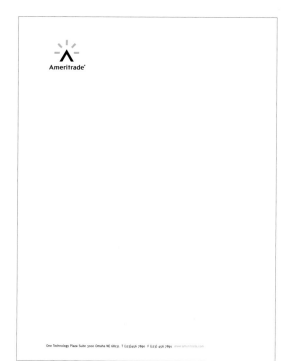

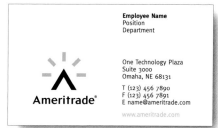

On the Mark

Once the client had approved Interbrand's branding strategy blueprint, the team began to explore ways to express the brand visually. The design exploration included an extensive audit of competitors' identities, says Stephen Bass, Interbrand's creative director on the project. "We looked at colors, logos, symbols, and messaging to determine who was trying to own what portion of the category." The team noticed a tendency for competitors to use "blue-chip" colors and iconography, and realized that Ameritrade needed to set itself apart from these more traditional approaches.

The design team created wordmarks and logotypes exploring the Ameritrade name and experimented with symbols that could work hand in hand with it. Among fifty or sixty initial concepts were abstracted Internet symbols, a bridge, and images that addressed Ameritrade's ease of trading. The team narrowed the list to eight or ten before presenting them to the client along with mock-ups that simulated various applications.

Based on feedback from the Ameritrade team, Interbrand took two or three logos back to the drawing board for refinement, including one concept that visually represents the point of contact for Ameritrade users—the cursor symbol. "It immediately became a metaphor for the point of contact between the user, the machine, and the marketplace," explains Larsen.

Moved to almost a 45-degree angle, the simplified arrow symbol resembles an "A" (or a pyramid or mountain) surrounded by "energy bars" representing what happens when you click it. "It's open to interpretation, but not confusing," Larsen adds. "It's an identity that's been refined and simplified to one symbolic element."

[above] *Letterhead and business cards were among the first applications for the new identity, but it came to life in a wide range of media, from television to direct mail and, of course, the Web.*

Creating & Protecting the Ameritrade Brand

Ameritrade Brand Mark Usage Standards September 2000

Using the Ameritrade Orange

Orange is distinct to Ameritrade within it's category, and as such is a valuable asset that should be used sensitively and carefully.

A new orange (Pantone 021C) has been chosen to better represent the orange of the Web based offering, and to make the halo of the Symbol more pronounced.

When using the color, the general principle is less is more. As a splash of color that is largely restricted to the halo of the Symbol, it appears more special, and actually has more impact because of it. The other corporate colors (black, white and gray) and the Supporting color palette have been chosen to ensure that the distinctiveness of the Orange can always be preserved.

less is more

The total area of orange should not exceed the amount shown in the Color Proportion sections of these Standards.

The Ameritrade Orange should never be used as a tint. Always pay particular attention at the production stage of any job to ensure that the Ameritrade Orange is as close a match to Pantone 021C as possible (on uncoated paper stock, match to Pantone 021U).

The Ameritrade Typeface

Typography is an important tool in building a distinctive and unique brand identity. The Ameritrade system uses one font, Meta. It has been chosen to communicate clarity, no-nonsense value and speed. It is modern (but not so 'trendy' it will date quickly), clean and works very well across all media, from print to web.

Having one corporate font clarifies communications, but does not have to be limiting; by exploring color, composition and scale, this one typeface can express a wide range of messages for many different audiences.

Meta

Meta Bold (Italic available)

ABCDEFGHIJKLMNOPQRSTUVWXYZ
abcdefghijklmnopqrstuvwxyz
1234567890

! @ # $ % ^ & * () _ + } { " : ? >
‹ œ ´ ® †¥¨^ø "'æ…© ƒ ß å ff
ç ¯µ ffi º – ≠ º ª • ¶ § ¢ £ ™ i

Meta

Meta Normal (Italic available)

ABCDEFGHIJKLMNOPQRSTUVWXYZ
abcdefghijklmnopqrstuvwxyz
1234567890

! @ # $ % ^ & * () _ + } { " : ? >
‹ œ ´ ® †¥¨^ø "'æ…© ƒ ß å ff
ç ¯µ ffi º – ≠ º ª • ¶ § ¢ £ ™ i

In instances when Meta is not available (HTML for example) please use **Arial**. Use **Times** for letter body text.

Meta can be purchased through FontShop International
Meta ©1994 Markus Hanzer for FontFont release 12.

[right—top] *When the Ameritrade identity began to suffer from inconsistent use, the company asked Interbrand to develop a detailed standards guide. The Ameritrade Brand Mark Usage Standards were sent to Ameritrade staff and agencies on CD-ROM.*

[right—middle] *Departing radically from the starchy, conservative looks of Ameritrade's competitors, Interbrand chose an arresting color palette of orange and black. Ameritrade's standards guide details how the color should (and should not) be used.*

[right—bottom] *The Ameritrade identity includes only one typeface: Meta. Clean and modern, but not trendy, it reproduces well in print and on computer screens. When Meta is not available (HTML, for example), Interbrand specified using Arial.*

Bass says the mark's simplicity served other purposes as well. In 1997, with Web-based graphics technology still evolving, designers had to create a mark they knew would reproduce crisply on the computer screen. "You don't know whether someone is going to be viewing this on a 21-inch (53 cm) monitor or a Palm Pilot, so you want to make sure it looks good in every situation. If it didn't work well on the screen, it wasn't the right logo for them."

It was an unorthodox symbol for the financial services industry, but again, Ameritrade was willing to break new ground. So the design team paired it with Meta, a clean and contemporary typeface, and rejected the conservative color palettes favored by Ameritrade's competitors. They chose a rather edgy orange and black that Larsen calls "fun, friendly, and approachable, but with flair." The team later added dark blue to fill out the palette.

An Eye to the Future

One of the project's main objectives was to produce a mark that could work well in a wide range of applications, from television ads to the Internet to printed brochures and direct mail. To ensure that the mark would be used consistently, Ameritrade asked Interbrand to develop detailed visual identity guidelines to help Ameritrade staff and agencies make brand-wise decisions when applying the identity.

Once the mark was adopted, Ameritrade committed a huge budget to marketing its new identity. The company grew exponentially during the next three years, with a 600 percent increase in revenues from 1997 to 2000, and a 400 percent increase in market capitalization during the same period.

In 2000, Ameritrade asked Interbrand to develop a brand definition study that would provide a living blueprint for the growth of the brand. Rounds of research consolidation, management interviews, customer experience studies, and reviews of existing positioning work resulted in a "brand essence" document based on the value, speed, and ease of use positioning pillars.

With an eye toward the future, Ameritrade also asked Interbrand to develop a brand architecture model that encompasses a naming strategy for new and future acquisitions and a migration program to leverage new subsidiaries' existing brand equities. Using the "masterbrand model," Ameritrade will be able to effectively shepherd the brand through the company's growth and ensure the brand message stays clear.

"Creating a great identity is only a starting point," notes Bass. "It has to be protected and evaluated frequently so that it stays relevant. As the brand category takes advantage of the trails blazed by frontrunners like Ameritrade, you sometimes need to revisit the brand and ensure that it still has an edge." ■

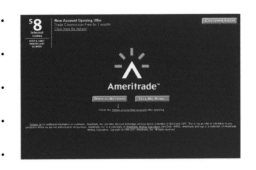

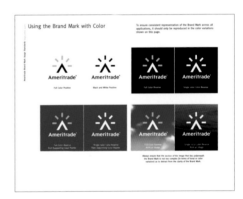

[above—top] *Ameritrade's Web site reflects the look and feel of the new identity.*

[above—middle & bottom] *Interbrand added dark blue to the Ameritrade palette (middle) and provided detailed guidelines about how the brand mark could be used with color (bottom).*

EQUITY MARKETING, INC.

11444 W. OLYMPIC BLVD SUITE 300

LOS ANGELES, CA 90064

EQUITY MARKETING, INC.

11444 W. OLYMPIC BLVD., LOS ANGELES, CA 90064
SUITE 300

310-231-6000 FAX 310-231-6010

KIM THOMSEN
SENIOR VICE PRESIDENT
CREATIVE DIRECTOR

Equity Marketing Inc.

A toy company learns to have fun with its identity.

Equity Marketing Inc. may be best known for the wildly popular collectible toys it designs and markets for Burger King, Arby's, and other fast-food chains. Founded in 1983 in a New York loft, it had achieved phenomenal success by the mid 1990s, when it added a division selling toys directly to consumers. But its old identity looked too "corporate" for the company it had become. Equity needed a fresh new image to reflect its expanded horizons.

[above] *(Before) Equity Marketing's old identity looked very corporate and bore little visual reference to a toy company.*

Kim Thomsen, Equity's chief creative officer, had seen the work of Redding, Connecticut-based Alexander Isley Inc., and liked what she saw. "He wasn't one of those designers who had a specific look and feel that he layered onto whatever he was working on at the time," notes Thomsen. "His work was varied and fairly conceptual, and most important, a little 'bent,' which is what we needed."

Multiple Messages

Equity knew its corporate identity needed to say more about the company than its slightly stodgy name did. "We needed to counterbalance the seriousness of our name with something playful, fun, smart, and hip," Thomsen says. The identity also had to speak to three very divergent audiences: the film and television studios Equity works with in licensing and designing toys, the investment community, and children. And it would have to look good in many different applications, from letterhead to animation and packaging.

e Equity™ Marketing

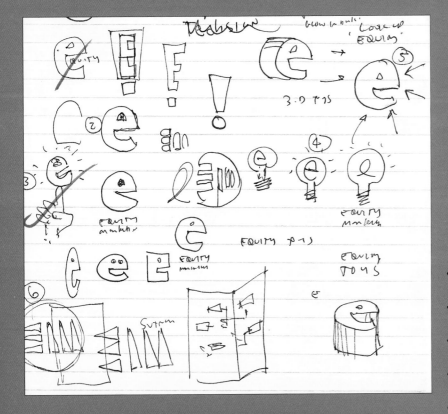

[above] *(After) The "e" is custom drawn based on the typeface Avenir, which itself is a redrawing of Futura, says Isley. "It's got a nice chunky quality, round and childlike in the best sense of the word." The dot in the middle transforms the mark into a character representing Equity Marketing.*

[left] *Alexander Isley explored several approaches for the new symbol, including using "equity" as a prominent feature. His sketches quickly veered toward making the "e" the most defining element.*

Client: Equity Marketing Inc., Los Angeles, California
Kim Thomsen | vice president of marketing

Design Team: Alexander Isley Inc., Redding, Connecticut
Alexander Isley | principal/creative director
Charles Robertson | senior designer
Aline Hilford | project director

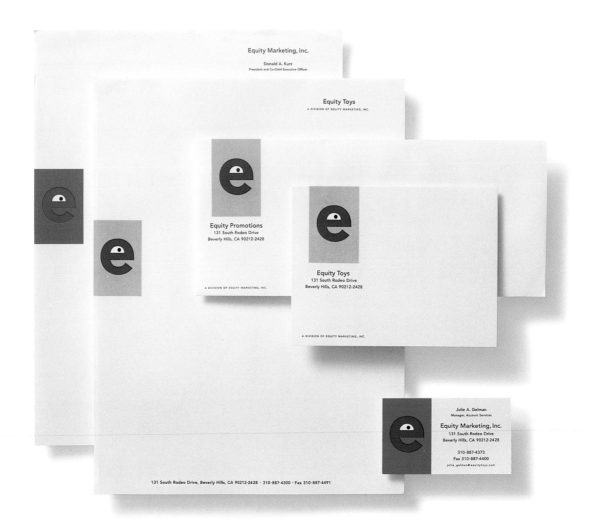

[above] *Isley created a warm color palette of turquoise, ocher, and red, which is used on letterhead, business cards, and other stationery pieces.*

As he does with all clients, Isley started by asking the Equity management team to complete a simple questionnaire that would set the project's direction. It included questions such as: "How do you want Equity Marketing to be perceived in the marketplace? What are the company's strengths and weaknesses? Who are your competitors?"

"This gives us an opportunity to identify and discuss any disagreements among the decision-making team before we start designing," notes Isley. "We typically present the findings and give everyone a chance to sign off on it. It saves a lot of time in the long run."

A Mark of Character

Once the project objectives were set, Isley's task was to transform the Equity Marketing name into an easily identifiable mark, one that had more of a connection to toys and fun than the existing identity.

Isley's early concepts included visual treatment of the word "equity." Although it's a strong word, it looked awkward on its own and its letterforms didn't fit

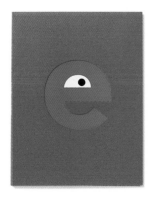

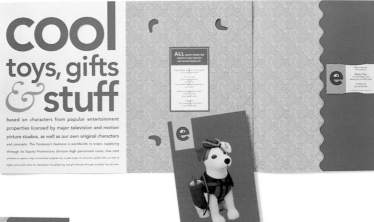

[top] *The press kit can be tailored to different audiences. Various product inserts are placed inside, and custom-printed belly bands make the kit seem new for every tradeshow.*

[middle] *A silkscreened plastic presentation cover was kept clear on one end so that Equity can customize it for various presentation needs.*

[bottom] *Equity has applied the mark to everything from products to packaging and annual reports. Its 1999 Consumer Products Kit was designed to market the consumer toy division.*

[above] *Equity Marketing's annual report features the symbol prominently, with its bold, photodimensional rendering of the mark.*

together well. Using initials didn't convey the personality the team wanted. He also explored representing the company with a stylized toy shape, but considered that too limiting. And, because Isley believes truly abstract symbols (such as the CBS eye or the AT&T globe) are only for huge companies that can afford to saturate their audiences through constant repetition to ensure the name is linked with the symbol, he steered away from this approach.

So Isley's early design explorations veered toward making the "e" the most prominent feature. Among the rough sketches he presented to his client was the final solution: a chunky sans-serif "e" with a simple but eloquent dot in the middle that transforms it into a witty, face-like symbol.

Equity management loved the symbol, both for its spirit of fun and because it worked equally well with the names of the company's two divisions: Equity Toys and Equity Promotions. It also reproduced well in various sizes and colors.

"Alex has taken something as simple as the letter 'e' and transformed it into a character, really," Thomsen says. "It's incredibly clean and graphic, and at the same time, there's this anthromorphized feeling to it. We think it's amazing."

Isley applied the new logo to stationery, using distinct colors and type treatments for the parent company and the two divisions. The "e" symbol and a colorful palette of turquoise, ocher, and red were continued in a customizable press kit used to help launch the consumer division at industry tradeshows. Isley also created a presentation format and cover as well as a card announcing the company's relocation.

Leaving Room for Fun

To guide Equity in the identity's implementation, Isley designed a two-page standards guideline that incorporates basic color and typography standards, but leaves a lot of leeway for the Equity creative staff. "It allows some room

for interpretation, which I think is fine for a company of this size with a creative staff," Isley notes. "It wouldn't work for a huge insurance company, but Equity didn't need a strict set of standards. To me, it's more important for the spirit and sensibility of the identity to be consistent, rather than uniform. It allows them to have a little fun with it."

And, they have. Equity has applied the logo to numerous applications, from product packaging to annual reports (including a memorable one that includes a moving doll's eye in the middle of the "e"), as well as the company Web site and numerous brochures. "We've been very creative with it," notes Thomsen. And, while she admits the logo has occasionally been mistreated graphically within the company, her department is generally able to function as "brand police."

Thomsen says the new identity has been an invaluable asset for Equity Marketing, whose business has continued to grow since the identity was adopted. "It's the foot you put forward in the world," she contends. "It tells the world we're smart and funny and left of center and just a bit irreverent. That's our brand personality in one simple mark." ■

[above] *Equity's Web site (www.equity-marketing.com) features the new identity in a playful way. The "eye" in the middle of the symbol roams freely, and Isley's original color palette also predominates.*

[left] *The Equity mark is also applied to toy packaging.*

Headstrong

A high-tech consulting firm steps into the "next generation" with a hip new identity.

James Martin + Co. had been a major player in the information technology (IT) consulting business for twenty years. Its founder invented the concept of "information engineering," the methodology behind development of IT systems. In the 1990s, the firm's business model had transitioned from telling companies how to implement new systems to actually implementing the systems themselves. With this change of focus, James Martin + Co. chose to create a new identity that would reflect its leap to the cutting edge.

[above] *(Before) James Martin + Co. had been a successful IT systems consultant for 20 years, but when it reinvented itself as an e-solutions provider, it need a new name and identity to signal its leap into next-generation consulting.*

[opposite page—bottom] *To visually capture Headstrong's brand message, The Leonhardt Group experimented with concepts of heads and abstracted representations of brain power, forward thinking, and collaboration.*

But in 1999, the company undertook a three-month self-examination to assess its industry and determine its future path. Recognizing that technology is changing the way most companies do business, James Martin + Co. decided that it too should change. So it acquired several other consulting firms and almost $200 million in venture capital to reinvent itself as an "e-solutions" provider that helps Fortune 500 companies exploit the Internet and other emerging technologies.

To signal its leap onto technology's cutting edge, the company needed a new name and a strong new identity to communicate its vast knowledge base and its leadership in the market. "We also wanted a name that had impact and would evoke a reaction," notes Kevin Murphy, the company's chief creative officer. "We didn't see the point in having a name that people were ho-hum about. Even if they hated it, they would be intrigued enough to wonder about the story behind it."

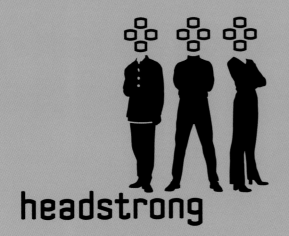

Client: Headstrong, Fairfax, Virginia

Kevin Murphy	chief creative officer
Liz Shepherd	brand launch director
Cindy Abell	senior marketing manager

Design Team: The Leonhardt Group, Seattle

Steve Watson	creative director, designer
Lesley Feldman	designer
Ron Sasaki	director client services
Sally Bergesen	brand strategist
Anne Connell	director brand development
Lesley Wikoff	production artist

[left] *Headstrong's new identity, three silhouetted figures with monitor heads, suggests the melding of technology, business, and people. The monitors represent the idea of collaboration.*

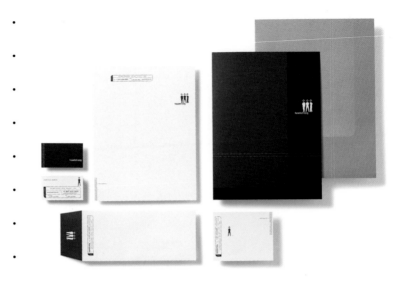

[right] *Designers added some unique touches to Headstrong's business papers. The envelope flap is black and vertically oriented. To emphasize Headstrong's global reach, a vertical time clock in the lower left corner of the letterhead is customized to individual offices worldwide.*

[below] *A Global Identity: The Headstrong executive team wanted its symbol to represent all types of its employees—men and women from various cultures around the world. So The Leonhardt Group developed an archive of fifteen different figures that can be interchanged in some applications, such as business cards. The primary set of figures includes two men and one woman. One of the men wears a barong, traditional business attire in many parts of Asia, where Headstrong has several offices and many clients.*

As part of its self-assessment project, the company had worked with The Leonhardt Group (Seattle) on an initial brand audit. They asked The Leonhardt Group to give the company a name and a face.

All in a Name

The company's competitors are Big Five consulting firms and dot-com startups, several with what The Leonhardt Group calls "ant colony" names—Sciant, Viant, and Sapient, to name a few. "With so many of their competitors having that techy, familiar sound to their names, we recognized that our client should zig to that zag and do something dramatically different," explains Steve Watson, creative director for The Leonhardt Group.

The name also needed to reflect the brand attributes of knowledge, collaboration with clients, and resilience. Another point of differentiation was the company's approach to consulting, says Watson. "There's a running joke in the business that if you hire a consultant, they'll just tell you what time it is," he explains. "That's not our client. They've been around for twenty years and they have a very broad knowledge base. And they're proud of the fact that their consultants are very opinionated. They have strong ideas about how to do things, and they aren't shy about telling their clients what they think."

The naming team kept all these attributes in mind as they generated more than 500 names during an eight-week period, and then narrowed them to ten names to present to the client. But, in the end, the naming team felt that strong opinions and a pool of brain power best characterized their client, which lead to their final selection—Headstrong.

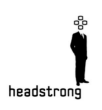

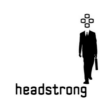

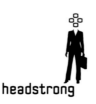

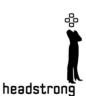

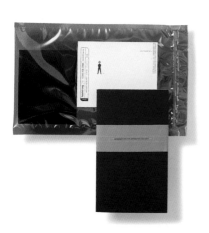

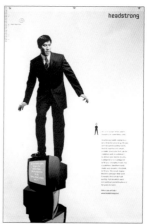

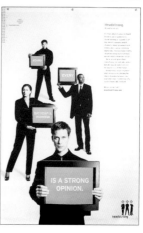

"Headstrong has very strong connotations of being strong-willed and opinionated, and it also speaks to the notion of brain power and a 'meeting of the minds,'" explains Watson. "It's a strong name for a bold, aggressive company."

The client team felt strongly about the name, but wanted to be sure it would translate well across the globe. To ensure the name played as well in China as it did in the U.S., The Leonhardt Group conducted linguistic and cultural research in sixteen languages. Headstrong passed the test with flying colors.

A Headstrong Identity

Once the name was approved, The Leonhardt Group moved on to a design exploratory phase. The team initially generated fifty or so concepts that interpreted the name along with visual treatments of its connotations, then narrowed the options to four for the client presentation.

"With that name, there were a million different ways we could approach it," recalls Watson. "We looked at the idea of a literal head, a more abstract 'techy' feel, simple logotype treatments, and visual ways to express collaboration and energy."

In the end, the team again opted toward differentiating Headstrong from its competitors. "The competition generally has this 'high tech' look, and we wanted to bring a human element into play," Watson explains. "We wanted to meld the idea of being a tech-based company with the idea that they are actual people."

[above—left] An internal launch brochure informed Headstrong's 1,100 employees about the new identity and the logic behind it. It also introduced the Headstrong color palette: primarily black and white, with shades of metallic blue that add an appropriately "techy" feel. Digitally-inspired patterns of concentric circles and squares add to the aesthetic. Headstrong consulted with a Feng Shui expert to ensure the identity was acceptable to Asian cultures.

[above] As part of Headstrong's internal launch, The Leonhardt Group created a series of oversized posters that more literally translate the Headstrong identity.

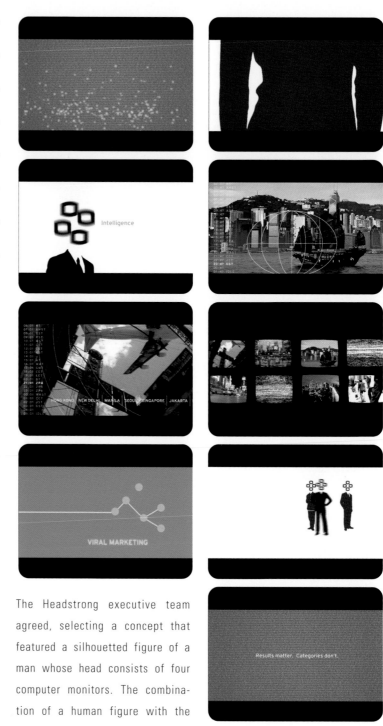

[right] *A four-minute digital movie premiered at Headstrong's internal launch party and is also used as a sales tool.*

The Headstrong executive team agreed, selecting a concept that featured a silhouetted figure of a man whose head consists of four computer monitors. The combination of a human figure with the high-tech equipment suggests the harmonious blending of technology, people, and business. "It also underscores that we're in the people business, and relationships are very important to us," notes Murphy.

The Headstrong team asked the designers to refine the concept, ultimately approving a symbol that incorporates three human figures. "As a global company, we wanted to make sure that all types of people in our organization, men and women from various cultures around the globe, are represented in the mark," explains Murphy. This desire for inclusiveness eventually produced an archive of fifteen figures that can be used interchangeably in some applications. The primary set of figures includes two men and one woman. One of the

men is clad in a barong, traditional business attire in many parts of Asia, where Headstrong has several offices and many clients.

Bringing It to Life

With the symbol approved, The Leonhardt Group continued exploring colors, type treatments, patterns, photography, and other elements of Headstrong's visual vocabulary.

Continuing the sophisticated, hip look of the silhouetted figures, black and white play a major role in the brand presentation. A palette of metallic blues and silvers adds to the "hipness quotient" and provides an appropriately "techy" feel, says Watson, yielding a rather James Bond-ish, spy aesthetic. "We never tried to hide that influence," he smiles. "The silhouettes are definitely reminiscent of James Bond movies. It's almost like we're telling a story about these hip techno-consultants who are hired to come in and turn things around."

The Leonhardt Group applied the identity to Headstrong's stationery system, created a media kit folder, a launch announcement for clients, and an internal launch brochure to help inform and sell the new identity to Headstrong's 1,100 employees worldwide. A digital movie was used for the internal launch and as a sales tool. As a backdrop for a huge employee launch party, The Leonhardt Group designed a series of oversized posters that photographically represent the new identity. They also developed the Headstrong Web site in collaboration with the Headstrong staff.

Results that Show

The success of the new identity has far exceeded Headstrong's expectations, says Murphy. "We expected some resistance both internally and from our clients, but on the whole, people are really captivated by it. Even if they don't like it right away, it's intriguing enough to them that they want to find out more."

Most important, says Murphy, the new name gives employees endless opportunities to tell the Headstrong story, and has even won the firm new clients. "When we lay our business cards down on a conference-room table, we immediately get questions about the name and the surrounding identity," he adds. "It speaks to our strengths as individuals as well as to our approach to working as a team."

One of the project's secondary objectives was to help Headstrong retain its key employees. Since the new identity was implemented, the company's attrition rate has decreased dramatically, from seventeen percent to just two percent, and "we can't stay on top of all the inquiries we're getting from potential employees, including people from our competitors," notes Murphy. "The young, hip aspect of the identity has been a huge bonus." ■

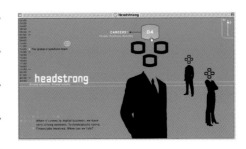

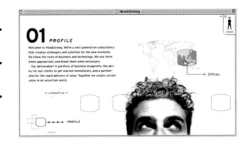

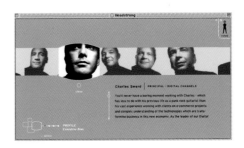

[above] *The Headstrong Web site incorporates the look and feel of the identity system. The monitors on the figures' heads do double duty as navigational tools.*

Hungry Minds | # A publishing company explores the possibilities beyond its IT roots.

When IDG Books Worldwide purchased hungryminds.com, an e-learning company, in August 2000, its portfolio already contained some of the most popular book brands in the world. Its award-winning For Dummies® series had made it the world's best-selling computer books publisher, and its other titles, including Frommer's® Travel Guides and CliffsNotes®, had helped IDG carve a niche as the publisher that makes challenging topics more accessible.

[above] *(Before) When it acquired hungryminds.com, IDG Books Worldwide was the publisher of some of the world's most popular book brands, such as the For Dummies® series, Frommer's® Travel Guides, and CliffsNotes®. It had moved away from its mission of providing books on information technology, and needed a new name to signal the change.*

For IDG Books, the acquisition was one more step away from its founding mission. Established in 1990, with seed money from its parent company, International Data Group (IDG), IDG Books was created to publish books on information technology. During the advent of personal computing, IDG had pioneered the industry, publishing information technology-focused news weeklies and magazines such as *Computer World* and *PC World*. IDG Books was considered a logical extension of the mission to provide IT information to a new, computer-driven age. IDG Book's first book, the seminal *DOS for Dummies*, was the springboard for a series that has by now been translated into thirty-nine languages, with more than 100 million books in print.

But as the For Dummies series grew increasingly popular, it also expanded in focus, says Mark Mikulvich, senior vice president of strategic brand management and business development for the company. IDG Books expanded the formula to topics as far-reaching as gardening, cooking, and fishing, and soon

Client: Hungry Minds Inc., Foster City, California

John Kilcullen | ceo

Design Team: Addis, Berkeley, California

Steven Addis	chairman
Ron Vandenberg	chief creative officer
Tom Holownia	senior vice president
Suzanne Haddon	senior designer
Chris Nagle	design director
Kristine Hung	brand director

began acquiring book titles outside the IT realm. "Over the next few years, we came to define ourselves not as being solely dedicated to IT," says Mikulvich, "but as having the core purpose of enriching people's lives by making knowledge accessible."

With its acquisition of hungryminds.com, IDG gained new inroads into the distance learning market (hungrymindsuniversity.com offers up to 17,000 e-courses from top universities and subject experts). Just as important, says Mikulvich, it gained ownership of a compelling name that could also serve as the company's consumer umbrella brand.

"IDG Books was no longer the most appropriate expression of our purpose as it had evolved," notes Mikulvich. The company had been considering possible new names for months, but had not identified an appropriate name that was also trademark and Internet-available. They considered Dummies Inc., he adds, "but that was just one light on our Christmas tree. After we acquired Hungry Minds,

[above] *(After) The new logo reminds us that all things are possible "when pigs fly."*

Brand Positioning

Hungry Minds is the preferred destination for applicable knowledge
and know-how. Whether it's to quickly close a small gap in one's understanding in order to solve an immediate problem or far more formal accreditation, Hungry Minds is the resource for those who want to know and know-how. Through its expanding blend of established and emerging media, the Hungry Minds experience provides access to a broad spectrum of trusted content

Brand Essence

Knowing

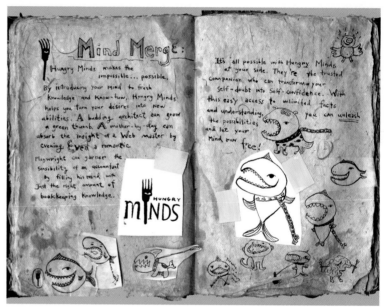

[above] *The Addis Group boiled Hungry Minds' offering down to the concept of knowledge and how it empowers people to achieve their goals and dreams.*

[across top] *Based on the brand positioning, Addis developed three alternative "brand ideas" that could potentially express Hungry Minds' brand essence. "Mindmerge" (bottom) was the direction Hungry Minds opted to follow for logo explorations.*

we began to realize that its name expresses our customer base perfectly—those who want their lives enriched through knowledge. And we owned the name—lock, stock, and URL."

The company called on Addis (Berkeley, California), to develop a corporate identity that would express Hungry Mind's evolved mission and reflect its ever-expanding content offering. The new brand needed to leverage Hungry Minds' established reputation in book and electronic publishing, while planting a stake in the emerging world of e-learning.

A Brand for All

The most challenging aspect of the project was to develop a provocative and ownable mark that would be appropriate for all of Hungry Mind's products—from reference material and how-to books to distance learning and accreditation. "It also needed to resonate across a wide target audience, from

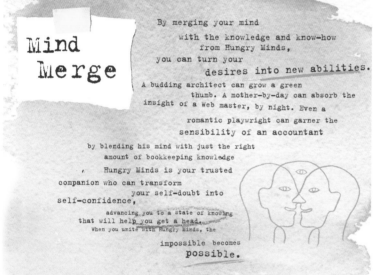

school-aged children to seniors, and from blue-collar workers to professionals," notes Kristine Hung, then an Addis brand director.

Addis started the process by analyzing existing market research and interviewing management to gain an understanding of the new brand, its competitive landscape, benefits, and attributes. Addis developed a brand positioning based on what Hungry Minds felt was its key differentiation in the marketplace: empowering people by providing knowledge that helps them achieve their goals and dreams.

Using the positioning statement and the concept of knowledge as its springboard, the Addis team developed three alternative "brand ideas" that could potentially communicate the essence of the brand. "Brand ideas move beyond the two-dimensional positioning statement and begin to define the creative range, tone, and manner appropriate for the brand," explains Hung. The brand ideas were used to inspire the Addis creative team as they brainstormed the brand's visual expression.

[above] *Addis presented seven logo options that hinged on the concepts of merging minds and feeding hungry minds. The flying pig illustration immediately caught the client's attention.*

Making their Mark

Addis ultimately presented seven logomark designs to the Hungry Minds team, but one quickly piqued the interest of the entire team. Based on the old saying, "When pigs fly," the logo concept portrayed just that—a winged, gold pig flying above the Hungry Minds name. With this whimsical mark, Hungry Minds could communicate to its audience that, with knowledge, everything is possible.

To ensure they had achieved the appropriate level of whimsy and credibility, the Addis team refined the mark and Hungry Minds added the tagline, "It's all possible," to reinforce the flying-pig reference. Addis offset the light-hearted nature of the illustration with more traditional typography (a classic-looking typeface based on Bodoni) and colors (a buttoned-down dark blue paired with metallic gold).

"It's really the metaphorical equivalent of 'anything is possible,'" explains Mikulvich. "It positions Hungry Minds as the catalyst that transforms the frustration of 'I can't' into the confidence of 'I can' by providing appropriate knowledge and content," he adds. "It's also fun and friendly, but communicates stature, reliability, and trustworthiness."

[above] *The new logo graces the spines of a wide range of books, from travel guides to cookbooks, dictionaries, and how-to guides.*

[left—top] *The final logo is a whimsical reminder of the old saying, "When pigs fly." The tagline reminds Hungry Minds' audience that, with knowledge, all things are possible.*

[left—middle] *The metallic gold logo appears on both a white and dark blue background. To balance the whimsical nature of the illustration with the credibility and professionalism Hungry Minds also wanted to express, Addis chose a slightly corporate-looking dark blue and a traditional typeface.*

[left—bottom] *On some applications, such as business cards, the new logo stands alone, without the tagline.*

To Market, To Market

Once the brand mark was approved, Addis brought it to life on stationery, templates for the company Web site, a corporate brochure, and other marketing elements. The team also produced a "Standards & Guidelines" document that defines brand architecture, typography, primary and secondary color palettes, and also illustrates the "dos" and "don'ts" of extending the mark to other applications.

Mikulvich says the new identity works well because it is aspirational, unexpected, and creates an emotional bond between Hungry Minds and its customers. "The mark was designed to be provocative and cause people to take another look," he adds. "It has also allowed us to shed the trappings of being purely an IT information company, and it doesn't paint us as just a book publisher. On more than one level, it's about unlimited possibilities." ∎

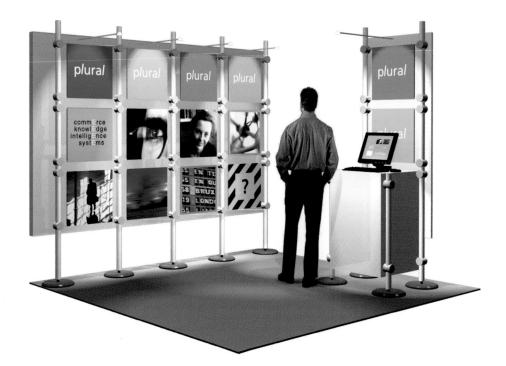

Plural | A traditional technology company retools for the Web.

Micro Modeling Associates Inc. (MMA) was a $54 million client/server consulting business serving the financial services industry. But when it began losing clients to dot-com upstarts, CEO Roy Wetterstrom launched a bold rebranding strategy to plant its flag on the Web landscape.

[top] *(After) A tradeshow exhibit prototype echoes the visible grid found in Plural's capabilities brochure. Designers envisioned a flexible, modular display system that could incorporate static or animated images.*

[above] *(Before) The company's original name, Micro Modeling Associates, was limiting because of its association with old-line technology. An interim move to MMA was a step away from the old, but didn't go far enough.*

Established in 1989, MMA was going strong a decade later as a developer of innovative client/server solutions for the financial services industry. But a shrinking market for client/server work and increasing competition—particularly from dot-coms encroaching into the market—signaled the need for change. CEO Roy Wetterstrom decided to redirect MMA's focus away from traditional client/server work and toward the digital world, creating a new Internet services, strategy, and development company.

To clearly broadcast its new mission, MMA needed a strong new name associated with leading-edge design and technology. "We needed to send a really loud message to the world that we were something new and something different," Wetterstrom recalls.

Research indicated that business-to-business customers were disillusioned with the competitors' tendency to sell "one-size-fits-all" solutions. So MMA wanted to leverage what it saw as its key point of differentiation in the market: a customized, three-pronged process that integrates strategy, creativity, and technology to develop client solutions.

Photographs: Andy Shen, New York

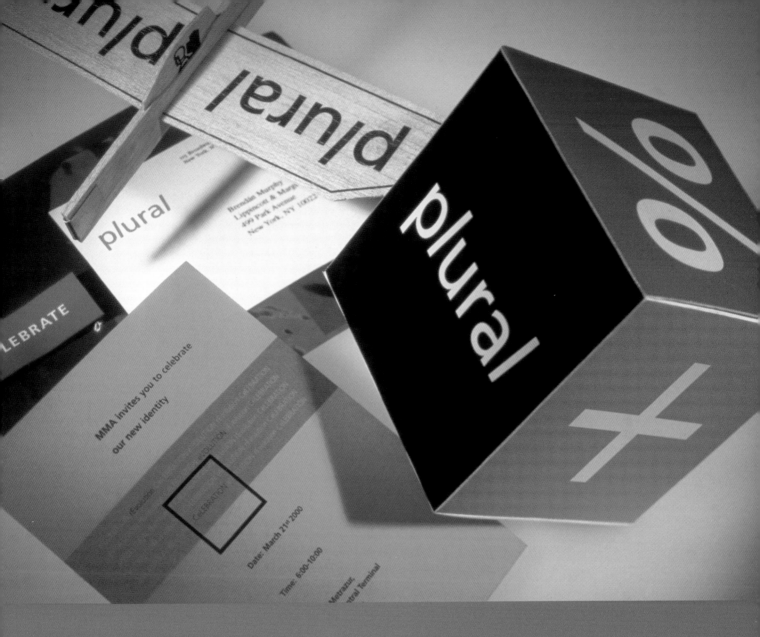

Client: Plural (formerly Micro Modeling Associates Inc.), New York

Roy Wetterstrom	CEO
Roy Wetterstrom	CEO
William Luddy	creative director
Connie Hughes	public relations manager
Emily Litz	senior marketing specialist

Design Firm: Lippincott & Margulies, New York

Brendán Murphy	partner/design director/designer
Jerry Kuyper	senior partner, design director
Connie Birdsall	creative director
Suzanne Hogan	senior partner

[above] *For its launch, Plural's
Web site echoed the look and
feel, organization, and messaging
content established in the
capabilities brochure. Later
refinements integrated layered
elements that underscore the
plurality and interactivity themes.*

[right] *A Plural palette of
orange, blue, green, red, and
yellow can be used in various
combinations on the logotype,
letterhead, print collateral, and
business cards. Plural
employees each have a rainbow
of cards, not just one color.*

Defining a New Identity

Lippincott & Margulies (New York) was brought on to help MMA articulate a
brand identity and express it in a new name, logo, and launch package.
Lippincott started the process by working with MMA to identify image attrib-
utes that would express the new brand's personality. Hundreds of names were
generated using attributes such as "modern," "creative," "committed," "solid,"
"confident," and "trusted." Finding a dot-com-available name further compli-
cated the process, says Connie Birdsall, creative director on the Lippincott &
Margulies team. "Identifying a name that describes what the company does
and stands for—and that is not already being used as an Internet domain
name—is a tall order these days," Birdsall explains.

Possible names were filtered through language experts, trademark lawyers,
and focus groups before MMA signed off on Plural. "I like it because it means
working together with our customers and with our partners," says
Wetterstrom. "And I was thrilled that we could get a six-letter Internet address
in English."

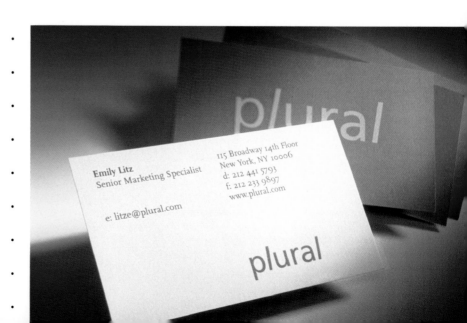

PLURAL **Plural**

plural plural

plural **plural**

pllurall pllurall

plural *plural*

plural *plural*

p*ll*ura*ll* p*l*ura*l*

p*l*ura*l* p*l*ural

plural

p*l*ural

p*l*ura*l*

[above] *Once they had arrived at the typeface and weight, designers tweaked the angle of the logo's two l's. Too flat an angle didn't get the point across (top), while too much hampered legibility (bottom). The middle logo was the winner.*

[left] *Early explorations of the Plural logo show how different type attributes changed the personality of the name. Designers experimented with upper and lower case, italics, bold and serif and sans-serif typefaces. They also played with using double l's to recall the Internet's backslashes. "Our goal," says design director Brendán Murphy, "was to not be too dot-commy or of-the-moment."*

Logo vs. Logotype

Next on the design agenda was a new Plural logotype. The team knew the logo needed to embody the spirit of client/consultant collaboration and emphasize Plural's three-pronged methodology. Since the new name was so strong, the team decided that rather than developing a separate symbol, it should embed the logotype with the desired image attributes.

The result was an elegant-but-friendly sans-serif logo based on the classic Frutiger typeface. Its two italicized l's reinforce the idea of "more than one" and are also a subtle nod toward the World Wide Web's ubiquitous backslashes. Use of lowercase letters keeps the mark friendly and is another nod to the Web, whose language is not case-sensitive. Designers created a palette of Plural colors—among them orange, blue, green, red, and yellow—that can be used in various combinations on the logo, letterhead, print collateral, and Web site.

[top] *Early ideation sketches resulted in a series of concepts later translated to the Plural capabilities brochure. These preliminary "look and feel" comps used contrasting design elements and different paper textures, colors, and weights to express the idea of plurality. Designers leveraged the square and a visible grid to marry the concepts of high tech and creativity.*

[middle] *Plural's capabilities brochure targeted multiple groups (including investors, the financial services industry, and potential employees), so it was conceived as a modular kit that could be customized to its intended audience. The 9x12-inch (23x30 cm) brochure is wirebound with section tab dividers and pockets that can hold 8^1/$_2$x11-inch (22x28 cm) case studies.*

[bottom] *Designers created a hierarchy of information by layering different sizes, weights, and textures of paper. In the "About" section, for example, the Plural story is told on a blue half-vertical page that allows a glimpse of artwork on the mylar page behind it.*

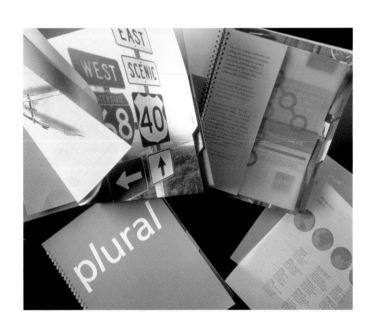

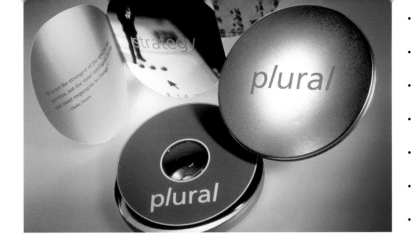

[left] *Lippincott & Margulies also developed a prototype CD that contained a Flash video version of Plural's capabilities brochure.*

[below] *T-shirts were one of several promotional items Plural sent to its constituents to create excitement around the launch. Other promos included balsa airplanes, Plural cubes, and launch party invitations mailed in anti-static microchip bags (page 71).*

Getting the Word Out

The design team's next task was to develop a capabilities brochure that would serve as a Plural launch kit. Working on an unforgiving three-week schedule—from concept to printing—the team was challenged with producing one kit that could be used for multiple audiences, including investors, the financial services industry, and recruits.

A modular solution seemed natural. Not only could it be custom built with its intended audiences in mind, it could also be printed in stages, which was necessary given the harrowing production schedule. So Brendán Murphy, partner and design director for Lippincott & Margulies, designed a 9x12-inch (23x30 cm) wirebound brochure with sections on Plural's history, capabilities, process, clients, and partners. And staying true to Plural's three-pronged approach, each section includes elements that speak to the company's use of strategy, creativity, and technology. Use of different materials—such as mylar and coated and uncoated papers in varying weights and textures—underscores the idea of plurality and adds a tactile quality.

While the aggressive rebranding schedule didn't allow time to develop a full-fledged style manual, the launch kit and supporting elements serve as a flexible and living design guide, says Murphy. "We were able to address things like clear space around the logo, where to position the logo on collateral, and the look and feel for the Plural visual system," he adds. Murphy's team also counseled Plural on the look and messaging content for its Web site.

Launched in early 2000, the new Plural identity was well received by clients and investors and the company looked toward an initial public offering (IPO). Plural was featured in the March 2000 issue of *Inc.* magazine. ■

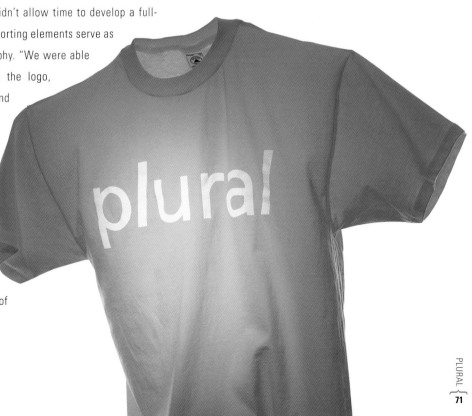

TABACALERA, S.A.

Tabacalera de España

A 400-year-old cigar maker repositions for the American market.

Founded in Spain in 1636, Tabacalera SA may be the world's oldest continuously operating corporation, and is certainly the oldest cigar maker. The Madrid-based company holds the rights to some of the world's most popular cigar brands, including Romeo y Julieta, Hoya de Nicaragua, St. Luis Rey, Quintero, and VegaFina. It has plantations, manufacturing facilities, and distribution plants around the globe.

[above] *(Before) Madrid-based Tabacalera SA, believed to be the oldest continuously operating corporation in the world, had used its classic tobacco-leaf emblem for many years. When it entered the U.S. market in 1997, it needed a bold new identity to promote its premium cigars.*

[opposite page] *(After) The new identity is both classic and contemporary, combining an iconic "T" with a modernized version of the tobacco leaf. The design is shown here on a poster used in retail stores, at tradeshows, and in Tabacalera factories.*

In 1997, through a series of high profile acquisitions and mergers, Tabacalera SA entered the U.S. market as Tabacalera de España. Peter Strauss, then the company's director of U.S. operations, knew his company needed to plan carefully to make an impact on the established American market. So, while guiding Tabacalera de España through the acquisitions that gave it a U.S. foothold, he retained Malcolm Grear Designers (MGD, Providence, Rhode Island) to create a new and unique corporate identity for the new company.

"In an industry as old as this one, where the well-established companies rule the roost, it's very difficult for a new player to come in and make a dent," explains Strauss. "We had to take advantage of Tabacalera's major advantage, which is its very rich heritage in cigar making and the fact that it is possibly the oldest continually operating company in the world."

The First Mark of the World's Finest Cigars

Client: Tabacalera, Madrid/Tampa, Florida
Peter Strauss | director of U.S. operations

Design Team: Malcolm Grear Designers, Providence, Rhode Island

[above—left] *For the launch of its American division at the Retail Tobacco Dealers' Association (RTDA) tradeshow, Tabacalera blended a special-edition cigar to give to attendees.*

[above—right] *Cigar bands were the most ubiquitous application for the new identity. To promote the individual product identities as well as the new corporate brand, cigars were double banded. The new corporate band needed to complement the existing product band.*

Old World Meets New

The new identity needed to respect and build on Tabacalera's heritage while, at the same time, strike a contemporary note that would appeal to the modern U.S. market, says Joel Grear, executive vice president of the design firm. The parent company's existing identity wasn't considered strong or sophisticated enough to appeal to American consumers with the means to purchase expensive premium cigars.

The new identity would also serve as an umbrella for Tabacalera's many cigar brands, adds Grear. "They owned many premium brands, but in the industry it wasn't well known that they were all produced by one company. So the new identity needed to unify all the brands under the Tabacalera name."

While researching the cigar industry, the MGD team noted that red was a recognized and accepted color that was not being prominently used by any of Tabacalera's competitors. So, as the team generated hundreds of logo sketches, it reserved red as a strong color possibility. The team also wanted the mark to reflect the roots of the industry by representing the tobacco leaf. "We wanted to evolve Tabacalera's existing identity, but make it more visible, more recognizable, and more forward thinking," recalls Grear.

MGD's solution paid homage to both the old and the new. An iconic red "T" provided a strong stamp of ownership, while a stylized red and black tobacco leaf inset in the letterform harkened to Tabacalera's roots and the parent company's history. Encircling the "T" with "Tabacalera de España, 1636" reinforced the historical aspect and created the look of an old seal.

Branding the Band

By far the most ubiquitous application of the new corporate mark was on cigar bands. Once Tabacalera's management team approved the mark, the company immediately began double banding its cigars: one band to feature the product brand, and the other to reinforce Tabacalera's corporate identity.

[top] *Malcolm Grear designers also created the look and feel for new packaging, including boxes for the hand-made RomeoSolo cigars. The wooden box features a romantically scripted "R" and a matching band. Inside, the top sheet is embossed with the Tabacalera symbol and the cigars are double-banded with the product and corporate identities.*

[middle & bottom] *Designers also created new packaging for the popular Romeo Y Julieta brand, including a series of romantic illustrations used on special seventy-fifth anniversary edition boxes.*

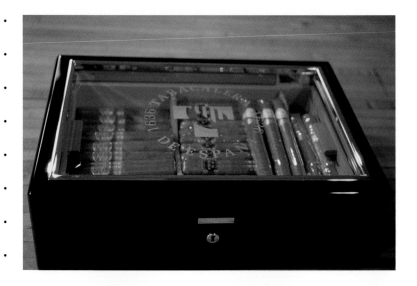

[above—top] *Tabacalera's corporate colors are blue and gold, so the new symbol was rendered in those colors for formal corporate applications such as business cards and stationery.*

[above—bottom] *Tabacalera's 50x60-ft. (15.2x18.2-m) booth at the RTDA tradeshow was a big hit, winning "Best of Show." A huge cigar seal suspended from the ceiling over the booth beckoned aficionados. Once there, attendees hung out in the humidor.*

[right—top] *Tabacalera commissioned the production of special-edition humidors to give away as premiums. The new mark was etched into the glass top.*

[right—bottom] *Among the many premium items designed for the new brand were cigars, lapel pins, and cuff links.*

Cigar boxes offered several points to reinforce the brand. The mark was printed on the boxes themselves, embossed on the outside seals, stamped on paper seals around the boxes, and embossed onto the paper top sheets that cover the cigars.

The design team also helped Tabacalera with product packaging. MGD created new boxes for the RomeoSolo and Romeo y Julieta brands and developed a new four-pack box for Tabacalera's introduction of its VegaFina brand at an industry tradeshow. The four-packs were so popular that Tabacalera asked MGD to refine the design for retail distribution.

Other applications included corporate stationery, promotional posters, and giveaways such as cuff links, lapel pins, t-shirts, and hats. The design also created a "Select Purveyor" award—a slate plaque that Tabacalera gave to its highest-selling retailers. And the booth MGD conceived for Tabacalera's most important industry trade show garnered it a "Best of Show" award.

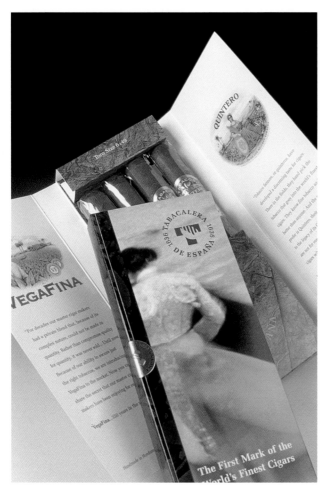

Success Story

In 1999, Tabacalera merged with the French company Seita to form Altadis, a leading European tobacco company. Just two years after it was developed, Tabacalera de España's new corporate identity became yet another chapter in the company's rich history.

But Strauss says the new identity provided the short-lived company with the visibility and impact it needed to crack the U.S. market. "It was extraordinarily successful, and we were able to impact the market in a very big way," notes Strauss. "Our brand quickly became very well recognized in the industry as a leading provider of premium cigars." ■

[above—left] *To introduce Tabacalera's new VegaFina brand at the industry tradeshow, Malcolm Grear Designers created a new four-pack. It was so popular that Tabacalera asked the designers to refine it for retail distribution.*

[above—right] *This pop-up point-of-purchase display housed the new four packs. Retailers who bought a certain number of the four-packs received the display free.*

An employee benefits company
Xylo | **sheds its discount image and heads for broader horizons.**

When employeesavings.com was established in 1997, its founders took a literal approach to naming it. Their business, after all, was exactly as the name proclaimed: discount purchasing programs that employees could access via proprietary Web sites. Focused on providing benefits that would help corporate clients increase employee retention, the company had developed its first programs for Boeing and Microsoft.

But when the Bellevue, Washington-based company saw opportunities beyond the discount purchasing realm, its name quickly became a liability. While it still provides purchasing programs, employeesavings.com shifted its focus toward "work/life solutions," programs that help employees balance their home and professional lives more effectively. Today, its offerings range from day care vouchers to travel planning and restaurant reservation services.

"Our name was too limiting and its connotation too low-value to reflect who we are, and it needed to change," says Judy Meleliat, senior vice president, marketing for Xylo. "Value is part of our offering, but we certainly don't want to be judged solely on that. To reflect our mission of providing work/life solutions, we wanted to reach a higher emotional level than just giving people an extra two bucks off something."

Meleliat, a former marketing vice president for Starbucks, was familiar with the work of Seattle-based Girvin and knew its staff included branding experts.

Client: Xylo, Bellevue, Washington

Judy Meleliat | senior vice president, marketing

Design Team: Girvin, Seattle

Kelsey Aanerud | account manager
Ann Bradford | director of strategic branding and marketing
Jennifer Bartlett | senior design director
Kevin Henderson | senior designer
Virginia Sabado | digital production senior
Alfred Astort | senior interactive designer
Barry Craig | senior interactive designer
Erich Schreck | interactive designer
Stephanie Krimmel | interactive developer
Erin O'Kelley | senior interactive producer

Her company needed that expertise, she says, to cultivate a name and brand that could grow over time, just as her company would.

A Strategic Foundation

Girvin's brand strategy group launched the project with a series of intensive meetings with the client's "thought leaders" to establish core values, brand personality, target audiences, and positioning. They also audited the company's existing marketing materials and those of competitors, as well as the company's business and marketing plans.

The research quickly steered Girvin toward defining and bringing to life the "work/life solutions" focus: simply, how the company is trying to improve employees' lives, and ultimately clients' bottom lines, through the programs it offers.

[above] *The new logo playfully communicates Xylo's mission to balance work and life. The circle punched out of the center of the "x" reappears inside the "o." "It's very clean and professional looking, but at the same time playful and approachable," notes Judy Meleliat, Xylo's senior vp of marketing.*

[above] *Girvin presented the client with a booklet full of possible names. They defined Xylo—the client's second and final choice—as "a captivating rhythm with individual style and appeal."*

[above—right] *Early logo explorations, including these thumbnails, focused on the letterforms, the idea of balance, and the company's human side.*

To explore branding directions, Girvin presented visuals representing three different facets of the brand personality: 1) "toolbox," a concept that emphasized the high-tech, dot-com connection; 2) "the power of the hive," which focused on working together; and 3) "time to be human," which focused on the value of relationships. "These gave a visual voice to different directions they could push their brand identity in," notes Jennifer Bartlett, Girvin's senior design director on the project. While the client team loved the "hive" analogy, they ultimately decided that emphasizing the human side of their business would be most effective.

The Name Game

With their visual compass now set, the Girvin team moved on to the naming process. A multidisciplinary team met initially to reiterate the brand attributes the work sessions had identified: relevant, aspirational, progressive, enriching, dynamic, and engaging. Each team member then generated a list of names, which were discussed, filtered, and passed on for trademark and dot-com checks.

When Girvin presented the first round of names, the client's decision was swift and sure, but fraught with complications. The chosen name, "applaud," was pleasantly upbeat and matched the client's brand attributes well. But it didn't meet the criteria of dot-com availability, and the client felt that owning the domain name was crucial. They decided to pursue purchasing the name, and asked Girvin to begin logo explorations. A few weeks later, their purchase attempts unsuccessful, they asked Girvin to generate another round of names.

As in the first round, Girvin presented a wide range of names, including actual words as well as word origins and created names. Meleliat's goal was to identify a word or part of a word that sounded familiar, but could be used in a new way. "We also wanted a name we could define over time, that could come to fit us and be associated with the products and services we provide," Meleliat continues. "We wanted it to sound friendly and inviting without carrying the burden of telling the whole story."

Meleliat found what she wanted in "xylo," which the naming team defined as "a captivating rhythm, with individual style and appeal." It felt familiar and somehow right, says Meleliat. "It's a truncation of the word xylophone, so it has melodic roots. It's also short and easy to remember, but it has depth and character. It just fits."

Finding Their Mark

Girvin launched immediately into logo explorations, working toward a mark that fit the brand personality as well as the new name. Fighting a tight deadline, Girvin presented twelve logo options to the Xylo team. Their unanimous choice was one of Bartlett's designs that playfully expresses Xylo's mission of promoting work/life balance—a treatment that punches a small circle out of the "x" and places it inside the "o."

"It speaks to the idea of balance, or it can be interpreted to be about one person and their life surrounding them," notes Bartlett. After experimenting with case and typefaces, Bartlett finalized an all-lower case brandmark based on a classic typeface that lends a professional, even corporate, look to the name. Connecting the "x" and "y" ligatures made it uniquely Xylo's.

[above] *Girvin explored a wide range of color palettes, from earthy tones to more daring combinations.*

[above–left] *Several internal rounds later, Girvin presented twelve possible logotypes to the client, including this group. "We always present logos in black and white first, because color can be so polarizing," says Jennifer Bartlett, Girvin's senior design director.*

xylo

[above] *Xylo ultimately opted for a more conservative palette of dark "business blue" offset by muted yellow and bright red. Green and purple are used secondarily.*

[right—middle] *Xylo's six-panel launch/capabilities brochure reinforces the company's mission to balance work and life by portraying Xylo clients and employees in their personal as well as business personas. Specially commissioned photographic portraits show them at work and play.*

[right—bottom] *Girvin also designed a bright red folder that contains the launch brochure, program feature sheets, and other marketing materials that Xylo distributes to prospective clients. It also features portraits of Xylo employees living their work and personal lives.*

Moving Forward

Once the mark was finalized in black and white, the Girvin team turned toward color palettes and designing a Xylo stationery system. They experimented with a wide range of color schemes, from earth tones to fluorescents. Ultimately, Xylo opted for a more conservative palette featuring a dark "business blue," bright red, and muted yellow, with touches of green and purple.

The next big step was a capabilities brochure that served as Xylo's launch vehicle. Continuing the theme of work/life balance, Girvin developed a concept that features profiles of Xylo clients in both their work and home personas. Seattle photographer Dennis Wise created portraits of the human resources professionals pursuing their favorite non-work pastimes. Girvin filled out the brochure with photos of Xylo employees pursuing their own hobbies.

The Girvin team moved on to creating a brand book/style guide and designing Xylo's tradeshow booth. Then, building on the branding and design foundation already established, Girvin's interactive team created xylo.com, a fifty-page Web site that features Xylo's "Connecting the dots" tagline and a theme of connectivity. Designers continued Xylo's messaging, color palette, and visual references, such as the black-and-white photos of Xylo clients and employees. A key element of the Web site is a Flash demo that is also used by Xylo's sales team for client presentations.

Meleliat says client response to the new name and identity has been resoundingly positive. "Once they understood we weren't taking away any services, but actually building on them, they bought into it quickly." Internally, Meleliat and her team worked hard to ensure that employees were informed about the identity change each step of the way.

The new identity has made the company feel "grown up," she says. "It has really raised the bar on the level of 'put together' that we try to convey. Once you have a corporate identity of this stature, you make a better impression and people listen differently. The world takes us seriously now, and so do we." ■

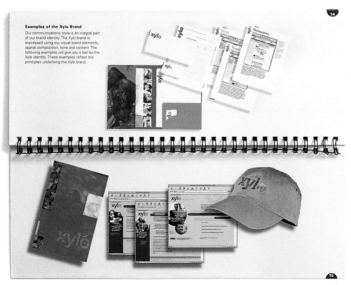

[above—top] *Building on the metaphor of connectivity and Xylo's "connecting the dots" tagline, the Web site was designed to communicate the same look, feel, and branding message as print materials.*

[above—bottom] *A Flash demo—featured on the Xylo Web site and also used as a sales tool—shows the private, co-branded Web sites Xylo creates for each client. Client employees use the sites to access premium products, services, and information.*

[left] *Xylo's brand book explains the logic behind the new identity and guides employees through use of the logo, graphic elements, and colors. Since it was for Xylo's internal use and Girvin didn't need to produce large numbers of the book, designers french-folded 8½x11 (22 x 28 cm) paper and wire bound it to create a long, narrow handbook. "We're always looking for ways to make 8½x11 (22x28 cm) more interesting," notes Bartlett.*

SEA CHANGE IDENTITY TO SIGNAL CHANGE

Some companies outgrow their original missions and need to communicate the change to their customers. Others need to overcome negative public perceptions or correct erroneous impressions about who they are and what they do. And others simply need to change their names to reflect new business directions.

In these cases, a new identity should help the company maintain any positive brand equities that already exist, but allow it to reintroduce itself to the marketplace in its new role. It's a delicate balancing act that often requires in-depth market research, customer satisfaction polling, and a crystal clear vision of not only where the business has been, but where it's headed.

Muzak is a perfect example of a company that needed to capitalize on its successes, but overcome negative impressions about its business. Hampered by its reputation as "the elevator music company," Muzak set out to modernize and redirect its identity to emphasize the emotional power of music and the artistic genius of its programmers, who create musical landscapes for retailers worldwide. The new identity helped to increase the company's market value sevenfold.

Hong Kong-based Powwow set out to revolutionize the United Kingdom's water cooler market. Not only did it want to dominate the market, it wanted to change the basic ways that business was done. It has accomplished those goals with the help of a new wordmark and a humorous, ongoing dialogue with its customers.

And France Telecom, formerly a government-owned telephone company, has transformed itself into a free-market powerhouse that now provides phone, mobile, and Internet service to 183 million people in more than 80 countries. A key factor in its success has been its new identity, based on an eloquent mark that symbolizes the benefits of communication and interaction.

France Telecom

A state-owned telephone company makes the leap from monopoly to global telecommunications competitor.

Faced with the privatization of its industry, France's former state-owned telephone company was forced to reinvent itself to enter the free market. Beginning in 1993, France Telecom did just that, embarking on a seven-year metamorphosis that transformed it into a highly competitive, publicly traded provider of phone, mobile, and Internet services. By 2000, France Telecom was a major player in European telecommunications, ranking as its second largest mobile and Internet service provider.

[above—top] *(Before) Before privatization, France Telecom's logo clearly identified it as "the phone company."*

[above—bottom] *(Before) In 1993, France Telecom asked Landor Associates to develop a new identity to help ease its transition from state-owned monopoly to free-market competitor. The new symbol distanced France Telecom from its telephone origins and suggested new technological horizons.*

In 1993, France Telecom commissioned Landor Associates (Paris) to create an identity system that would help ease the transition from state-owned monopoly to free-market competitor. In late 1998, it called on Landor again to take the identity one step further: the birth of a global service brand.

"Basically they went from being a government administration to a highly competitive telecommunications company in just a few short years," says Aaron Levin, Landor's creative director on the project. "They needed a strategic brand platform that would serve them well in their new global market"—a market that includes 183 million customers in more than eighty countries.

Client: France Telecom, Paris

Marie-Claude Peyrache	head of corporate communications
Olivier de Pierrebourg	brand director
Catherine Barnier	brand manager
Patrice Copin	brand manager

Design Team: Landor Associates, Paris

Aaron Levin	creative director
Patrick Brossollet	branding consultant
Didier Leduc	design director
Laurence Apard	senior designer
Frédéric Michaud	senior designer
Emanuelle Angibaud	designer
Ingrid Birraud	designer
Dominique Cabos	extension designer
Didier Burlurut	multimedia designer
Rémy Amisse	project manager
Ahn-Huan Tan	project manager

Taking Stock

The first step in the process was an extensive audit aimed at better understanding France Telecom's internal culture, its strategic vision, the internal and external forces impacting change, and finally, the technological innovations likely to shape its market in the future. Landor conducted one-on-one interviews and held group workshops with more than 100 key employees to gather input on such topics as how new technology will impact consumer needs, behaviors, and expectations.

Early research showed that, while French customers have positive attitudes about public utilities, they don't associate them with a high level of service. And, while customers were fairly attached to France Telecom's product brands, those brands were not at all reflected in the current identity. While a name change was considered early on (the word "France" was considered limiting given the company's global reach, and "Telecom" has old-technology associations), research showed that the public would reject a new name.

[above] *(After) The universal ampersand, rendered in a friendly style that suggests both technology and warmth, is the visual metaphor that communicates how France Telecom enriches customers' lives by facilitating relationships. A proprietary typeface and pictogram font make the symbols unique to France Telecom.*

florent lancem

[above] *The new identity needed to be kept top secret until launch day, so Landor showed a dummy logo to all but a handful of key decision-makers.*

[below] *This piece, designed for an employee incentive contest, shows the full France Telecom color palette: blue, orange, and red for the logo, supplemented by purples, pinks, greens, and yellows for print and animated media.*

Based on the research, Landor formulated strategic recommendations on the degree of change needed in the identity, brand equities that should be preserved, brand architecture, and retail strategy. It presented France Telecom's executive team with seven possible "brand drivers," Landor's term for a compelling idea that drives all manifestations of the brand.

Breaking Away

Landor had noted that the identities of France Telecom's major competitors fell into three basic categories, hinging on the idea of transmission (Deutsche Telecom and Sprint, for example), global reach (AT&T, Cable & Wireless), or human aspects (Cegetel and Bouygues Telecom). To break away from the pack, France Telecom needed to differentiate itself from its competitors. Landor realized its opportunity lay in expressing the end benefit of telecommunications, in line with France Telecom's vision that "a world with better communications is more likely to become a better world."

Expanding on the concept, Landor developed a unique brand driver, "The Extraordinary Richness of Combinations," which expressed how, through the synthesis of tools and technologies, France Telecom enriches consumers' personal and professional lives. Levin explains the concept further: "Telecommunications enhance your communication possibilities and expand your sphere of interaction. What's the benefit of that? When ideas circulate and combine, they give birth to new ideas. So in combination, all the elements of the product—phone, mobile, and Internet services—are greater than the sum of their parts."

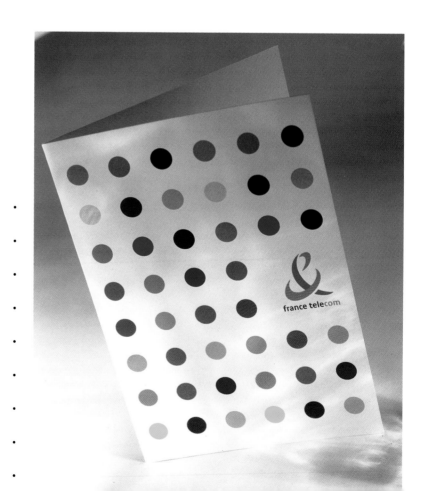

The design team took an innovative approach to helping France Telecom choose the direction in which the brand driver would be developed. It invited fifty key stakeholders to a special exhibition consisting of five "brand universes" that could potentially express the key ideas behind a new identity. Five rooms, informally named "Rhythm of Life," "Architects of the Future," "Intimacy," "Everyone Follows His Own Road," and "Imagineers," were outfitted with visual stimuli, musicscapes, smells, tastes, objects, furniture, and verbal evocations representing the five concepts.

Using feedback from the exhibition, Landor continued with its design explorations, exposing key executive team members to concepts along the way. Two final concepts selected by France Telecom's communications department were presented to the company's CEO and then tested in Europe, the U.S., the Middle East, and Asia to help anticipate any cultural issues.

An Eloquent Mark

The concept crystallized even further when the Landor team devised a graphic symbol that pulled all the elements together visually. The universal and ubiquitous ampersand, rendered in a friendly, warm version unique to France Telecom, became the visual container that communicated the value of interaction and relationships.

"The ampersand symbolizes bringing things and people together, and it will never go out of style," notes Levin. "It represents France Telecom as the enabler of relationships, going beyond the simple technical connection."

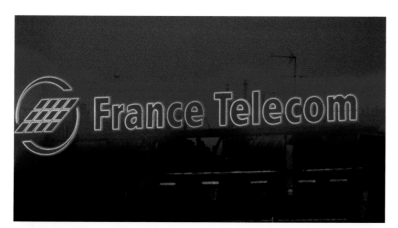

[left—top & bottom] *At launch time, France Telecom replaced its old sign (top) in the center of Paris with a new one (bottom) expressing the new identity and symbol.*

[right] *To help spread the word, France Telecom dressed the exterior of its headquarters in huge graphics that matched the look and feel of the ad campaign.*

[opposite page—top] *To inform France Telecom's 100,000 employees of the identity change, Landor designed a handbook-sized brand book that was included with their employee magazines. It relied mostly on images to tell the story of the new identity.*

[opposite page—middle & bottom] *The France Telecom identity was applied across a dizzying range of media, from product and corporate brochures to business cards, customer calling cards, and promotional items.*

Landor paired the mark with a proprietary sans-serif typeface. Its slightly rounded letters combine a sense of technology with a casual, human touch. To offset the official tone of the France Telecom name, designers used all lowercase letters. And to provide a visual link between France Telecom's old and new identities, Landor elected to keep its familiar blue, but warmed it with reds and oranges that add dimension and movement. Pinks and greens liven and expand the palette for France Telecom's numerous applications.

The Launch

The new identity was launched publicly in March, 2000 with an advertising campaign and a special celebration at a Paris rugby match. Long-time rugby sponsors, France Telecom dressed up the stadium with banners and signage featuring the new identity, passed out t-shirts to attendees, and introduced the new identity in a promotional video. It also unveiled a huge new logo sign in the center of Paris.

But when a company has more than 100,000 employees, an internal launch is just as important, says Levin. To prepare employees for the new look (which was kept secret until the launch), Landor created a small "brand book" that was included within a mailing of France Telecom's employee magazine. The handbook-sized guide didn't attempt to explain all the logic behind the new identity, says Levin, but relied mostly on images to persuade employees that the change was a good thing. The identity was also featured in a video shown on the internal television channel the night before the public launch.

Applying the new identity to thousands of customer touchpoints was a huge challenge. To ensure that the identity was launch-ready, Landor created downloadable templates of the logo, fax pages, and other correspondence tools. Stationery and business cards were available the day of the launch, and launch

 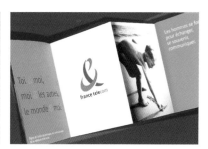

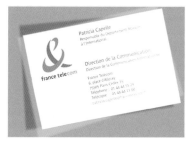

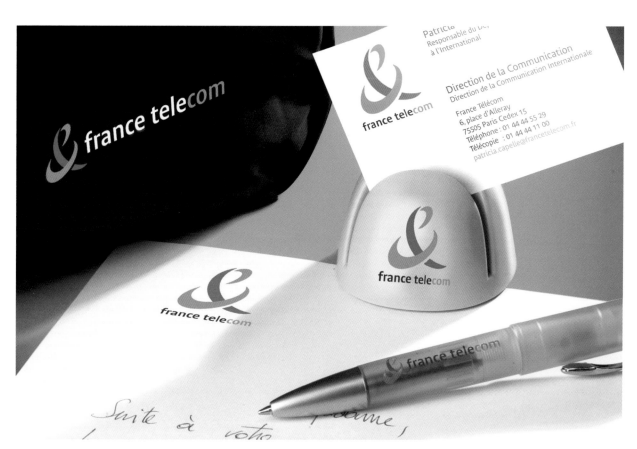

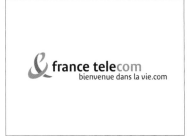

[right] *Still images from a promotional launch video show how the ampersand was used as a metaphor for relationships of all kinds.*

[below & opposite page—bottom] *Landor created an electronic graphic standards manual on France Telecom's intranet, as well as an abridged hard-copy version in handbook size. Proprietary fonts, pictograms, and other graphic elements are downloadable.*

kits were sent to France Telecom's 800 retail outlets. Other applications included literature, signage, shopping bags, promotional items, company vehicles, and 80,000 phone booths, which were redressed in new vinyl graphics. Landor also developed a graphics manual in both print and Internet-based versions to guide internal application of the new identity.

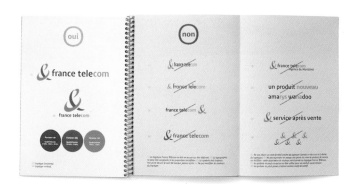

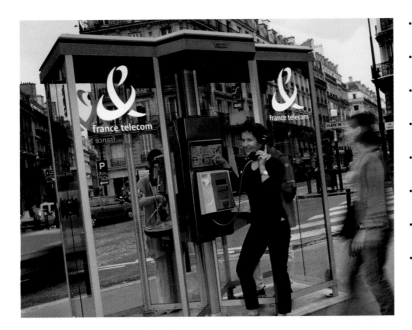

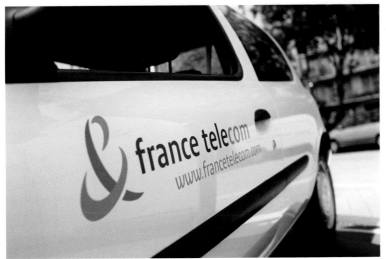

[left—top] *More than 80,000 phone booths were redressed in new vinyl graphics that display the new identity.*

[left—middle] *Thousands of company vehicles also received new graphic treatments.*

If customer awareness and design awards are any indication, the new identity is a resounding success. Landor's work on the project was recognized by *Stratégies*, a French magazine devoted to media and communications. Six months after the identity launch, Landor and France Telecom tested the new identity to determine how it rated on several key attributes, including "modern," "dynamic," "creative," "welcoming," "warm," and "Internet." The new mark consistently rated twenty to thirty points higher on each of these attributes than the old identity. ∎

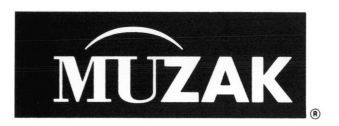

Muzak | The "elevator music" company orchestrates a hip new identity.

Sometimes a strong brand identity can be a double-edged sword. Muzak, which may enjoy one of the most recognized business names in the world, is a case in point. Muzak was a $300 million company by the late 1990s, but in the popular vernacular it had become synonymous with "elevator music," an outdated and decidedly unhip image that its top management felt was hindering sales.

[above] *(Before) Muzak's existing symbol, circa early 1980s, represented its old scientific approach to marketing, and didn't capture the emotional range of music that is now at the core of Muzak's values.*

Muzak was established in the early 1920s by General George Squier, who discovered that background music soothed his employees and increased their productivity. (Squier named the company by combining the word "music" with the name of his favorite "high tech" company, Kodak.) His patented technology also helped calm the riders of a new invention called the elevator.

"We hadn't done that as a company for eons, but the perception was still out there," says Kenny Kahn, Muzak's vice president of marketing. "It was time to accurately portray what we were all about."

Today, Muzak provides customized musicscapes to more than 300,000 retail and corporate subscribers and has the largest digitized music library in the world. The core of its success, says Kahn, is the group of creative people who make up the organization, including its music programmers, known as "audio architects."

Kahn sensed the most effective way to market Muzak was to emphasize the creativity, and emotional power of music. "We used to represent our product in terms of its scientific and physiological impacts," says Kahn. "That was old hat."

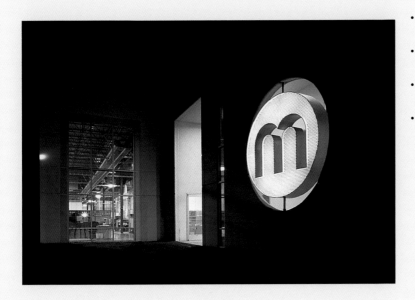

Client: Muzak, Fort Mill, South Carolina
Kenny Kahn | vice president of marketing

Design Team: Pentagram, San Francisco
Kit Hinrichs | principal/creative director
Brian Jacobs | associate/art director
and designer

So Kahn selected Pentagram (San Francisco) to fashion a new identity that would position Muzak as a creative, branded audio agency that shapes musical environments in a wide range of settings, from restaurants to retail.

"The assignment was essentially to take a brand identity with a lot of equity, some of it negative, and reshape the world's perception of it," says Kit Hinrichs, Pentagram principal and creative director on the project.

A Look Inward

Before Pentagram could articulate a new visual identity for Muzak, the team needed to examine Muzak's current self-image. Pentagram interviewed Muzak management and conducted a visual audit of existing marketing materials, discovering that the visual expression of the Muzak brand was "all over the map." As with most franchise-based operations, ensuring consistency had been a problem, agrees Kahn. "And as a company, we had put our brand aside for the last twenty years."

[above] *(After) In the end, sheer simplicity won out. Pentagram leveraged the letter "m," encircling it and giving it a softer, more approachable shape. The new logo is at once modern and sophisticated, but appealing and approachable. A neutral palette of silver and black simplifies its translation to various media.*

[right] *Logo explorations followed several different directions, including visual expressions of sound, suggestions of musical notes, and abstracted expressions of change.*

The Pentagram team knew that Kahn was frustrated with Muzak's existing marketing tools. "We needed to tell the Muzak story in a very compelling way that would change potential clients' perceptions and actually help their sales force sell the product," says Hinrichs. Kahn, the company's CEO, and the vice president of audio architecture, understood that dramatic changes were needed. Says Kahn, "We also saw a great opportunity to reinvigorate the organization by redefining our brand."

The executive team discussed changing the company's name, but only briefly. "We realized that although there were some negative equities in the name, there were many more positive attributes," Kahn explains.

A Sound Symbol

Pentagram knew Muzak's new identity should shift from the scientific focus of the past to a more creative, emotion-based approach. Logo explorations gravitated toward musical notes, visual expressions of sound, and abstracted expressions of change.

In the end, after several rounds of sketches focused on more intricate approaches, sheer simplicity won out. Limiting the symbol to the letter "m" created a dramatic statement and de-emphasized the Muzak name and any negative connotations attached to it. Encircling it created a universal appeal, and rounding the "m" and rendering it in lowercase added softness and approachability, says Brian Jacobs, Pentagram's art director and designer on the project. A proprietary rounded typeface, based on Futura, lent contemporary flair.

"We had to laugh because at the end of four months of logo explorations, we ended up with an 'm' in a circle," says Jacobs. "But it was really quite a revelation. We saw, and Muzak understood, how effective the simplicity would be for them." The symbol's understated appeal doesn't limit Muzak to its current product offering, and designers knew it would translate well to the many print and multimedia applications Muzak uses to promote the brand.

[left] *The simplicity of the new mark gives Muzak flexibility in adding new product lines, and translates well to a wide range of applications.*

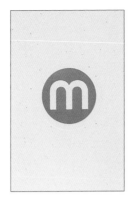

[above] *The cover above features the new Muzak logo embossed in silver on recycled paper. Inside, the brochure is short on text, but long on visual impact.*

[right] *Developing effective marketing tools for Muzak's sales force was a key component of the project. The 10x14-inch (25x36 cm), wirebound "Muzak is...." capabilities book ignited sales and won over both clients and employees. Pentagram used bold colors and typography to evoke music's emotional power and portray Muzak as an organization of young, hip, and knowledgeable "audio architects" who use music to reinforce their clients' own identities.*

In keeping with the "simpler is better" approach, Jacobs created a sophisticated, minimalist color palette of silver and black. "It's completely neutral," he explains. "And while the metallic element adds sophistication, color doesn't become a negative or positive attribute." The team decided to reserve color for adding pop to promotional pieces.

A Selling Force

While applying the new symbol to Muzak's stationery system, Pentagram began work on a key marketing piece for Muzak, the capabilities brochure that is one of its sales force's most valuable tools.

Based on a "Muzak is....." theme, the brochure chronicles Pentagram's discovery of Muzak as a multi-faceted, creative organization staffed by a young, hip, and knowledgeable staff. The oversized, wirebound book uses bold color and type treatments to evoke music's emotional power and introduce Muzak's offerings.

Kahn says the brochure made a major impact as soon as Muzak sales people started taking it to client appointments. "Sometimes they wouldn't get an appointment, but would leave the brochure behind. By the time they got back to their office, there would be messages from that person saying 'I want to see you!'"

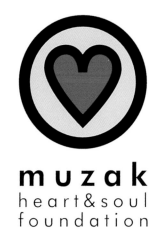

muzak
heart&soul
foundation

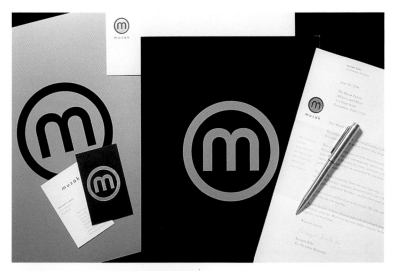

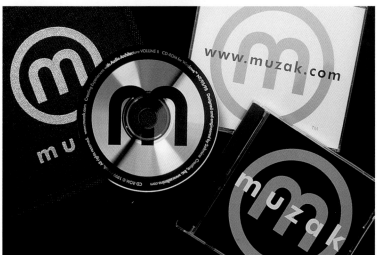

[above—top] *Pentagram also designed a symbol for the Heart & Soul Foundation, Muzak's not-for-profit organization that exposes underprivileged children to music.*

[above—bottom] *Subsequent brochures for individual Muzak product offerings used the graphic vocabulary established in the capabilities brochure.*

[left—top] *Applied to letterhead, business cards, and envelopes, the black-and-silver color palette is sophisticated but ultimately neutral. "Most often, people's negative reactions to a new symbol have to do with color," says Brian Jacobs, Pentagram's art director on the project.*

[left—bottom] *The shape and color of the new symbol were partially inspired by the shape and color of CDs.*

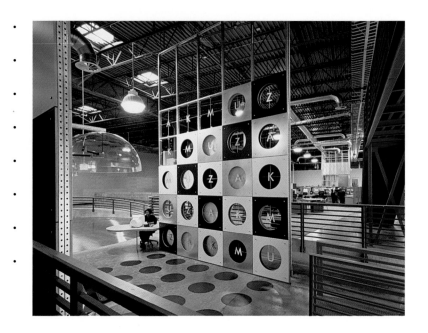

[above] *Muzak called on Pentagram's architectural partner, James Biber (New York City) to design its new corporate headquarters in Fort Mill, South Carolina. The new identity resonates throughout the building, from door handles in the shape of the mark to numerous circular themes and a predominately black-and-silver palette.*

[right] *A series of fun and funky promotional postcards signal to current and prospective clients that Muzak is no longer the "elevator music company." They communicate a young, hip attitude by linking Muzak's name with skateboarding, graffiti, and other youthful endeavors.*

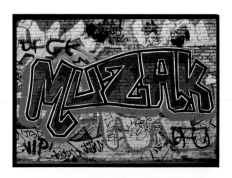

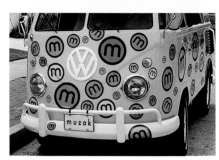

Pentagram applied the graphic language developed for the capabilities book to subsequent marketing materials and a Director-based multimedia presentation that sales people run on their laptops during client appointments. Muzak also decided to work with Pentagram on the ultimate expression of its brand message, its corporate headquarters. Pentagram's New York City office designed the new building and helped translate the logo and other visual elements into Muzak's workspace.

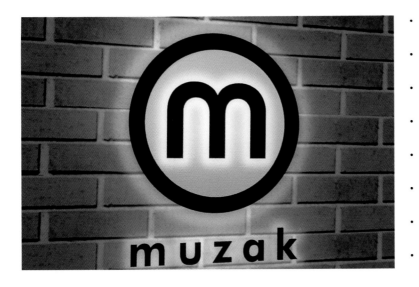

Results that Resonate

The new identity and sales tools have ignited the sales force and made believers out of Muzak's franchisees, says Kahn. After all, it's hard to argue with the phenomenal sales increases Muzak has seen since the new identity was launched in spring of 1998. During that time, he says, the value of the company has increased from $100 million to $700 million, and sales are still going strong.

"Music is the most powerful emotional tool that businesses didn't know they had to grow their own businesses," notes Kahn. "Pentagram gave us a visual foundation that lets us actively, creatively show people what music can do for them."

Even more important, says Kahn, the new identity has given the company a new pride in itself. "It made us feel good about ourselves, and when you feel good about yourself, you can go out and produce."

"Through design," he adds, "they gave our business a soul." ∎

[above] *The new mark also appears on company vehicles. One of the signs of a great mark, says Pentagram principal Kit Hinrichs, is its simplicity. "If people can remember it and draw it, that represents ninety percent retention."*

[left—top] *Pentagram designed several sign types to cover the various buildings where Muzak's offices are located. This sign consists of halo-lit metal and acrylic painted black and silver.*

[left—bottom] *A direct mail piece emphasizes the emotional power of music and how it can be used to grow business. This emotionally-based approach is a radical departure from the scientific-based marketing approach Muzak had used in the past.*

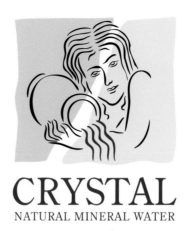

CRYSTAL
NATURAL MINERAL WATER

BRÆBOURNE

Powwow | # A water cooler company introduces its fresh new business approach.

When Hong Kong-based conglomerate Hutchison Whampoa entered the United Kingdom's water cooler market in 1998, its goal was to be the number-one water cooler business in the country. With ambitions to expand further into Europe, it acquired a number of UK-based water brands, including Braebourne and Crystal Spring, and began developing its marketing strategy.

[above] *When Hong Kong conglomerate Hutchison Whampoa bought into the United Kingdom water cooler market in 1998, it acquired two prominent brands, Braebourne and Crystal Spring, to gain a foothold in the market.*

But when your business is selling a product that is colorless, odorless, and virtually tasteless, it's difficult to differentiate yourself from competitors who supply a similar colorless, odorless, and tasteless commodity. In an industry dominated by "wells" and "springs," the new company needed to set itself apart from other suppliers. It enlisted the help of brand consultancy Wolff Olins to create a brand that would integrate the newly acquired businesses and position the company for leadership in the market.

A Fresh Approach

The key to building the brand, says Nigel Markwick, senior brand consultant for Wolff Olins, was to determine how to differentiate the company from its competition. Research showed that consumers lacked strong opinions about water brands, and the company's business-to-business clients were also neutral: they had no criticisms of the current service, but weren't enthusiastic about it, either.

Client: Hutchison Whampoa Ltd., [Hong Kong]

Ken Sheridan	director of global brand strategy, Powwow
Martin Thorpe	director of sales and marketing, Powwow

Design Team: Wolff Olins, London

Nikki Morris	account director
Nigel Markwick	senior brand consultant
Doug Hamilton	creative director
John Besford	lead designer
Lionel Chew	product designer
Tim Pope	product designer
Naresh Ranchandani	copywriter
David Rose	3-D designer
Vikki Olliver	account manager

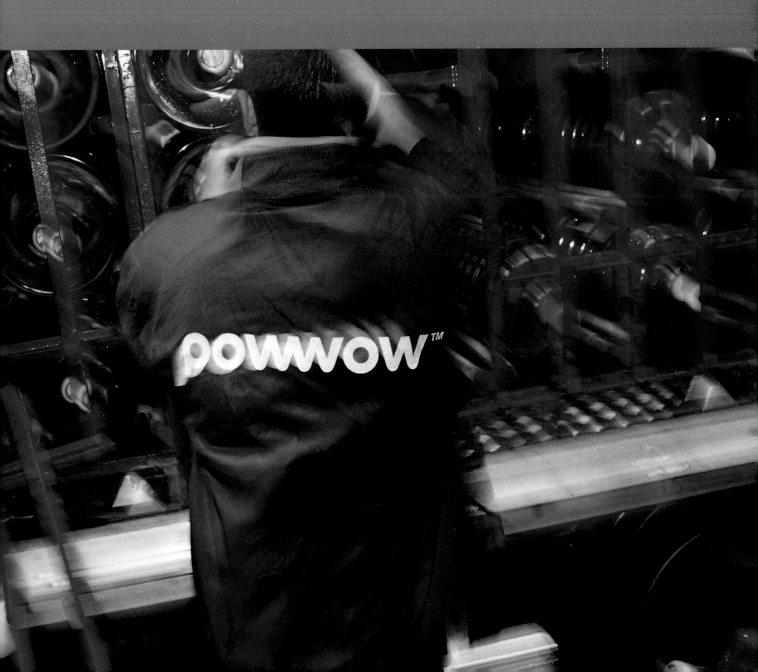

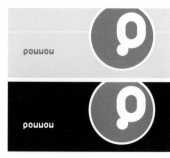

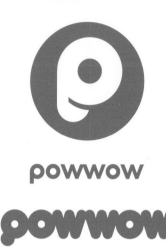

powwow

POWWOW

[above] *The Wolff Olins team quickly settled on a "fresh" brand platform and named the company "Powwow" to express the water cooler's function as an office meeting place and conversation starter. They explored several logo concepts, including marks that manipulated the "P" letterform playfully to evoke a bubble in a water cooler.*

[above—right] *The Wolff Olins team decided that a name as distinctive as Powwow didn't need a symbol, and narrowed its creative exploration to type treatments. This exercise shows how different typefaces can change the logotype's tone of voice.*

Powwow doesn't make you better at meetings. It does make you more regular though. Fresh water. Naturally.

Powwow doesn't make you better at meetings. It does make you more regular though. Fresh water. Naturally.

Powwow doesn't make you better at meetings. It does make you more regular though. Fresh water. Naturally.

POWWOW™

Powwow doesn't make you better at meetings. It does make you more regular though. Fresh water. Naturally.

PoWWoW

Powwow doesn't make you better at meetings. It does make you more regular though. Fresh water. Naturally.

PoWWoW

Powwow doesn't make you better at meetings. It does make you more regular though. Fresh water. Naturally.

PoWWoW

Powwow doesn't make you better at meetings. It does make you more regular though. Fresh water. Naturally.

POWWOW

Powwow doesn't make you better at meetings. It does make you more regular though. Fresh water. Naturally.

"Water didn't seem to inspire passion in anyone," observes Markwick. "And if you tried to base the brand on the product alone, there was nothing really to differentiate it from any other high quality water."

But the company was looking for more than just an identity, says Markwick. "They weren't just looking for a new logo. They needed a brand idea that would help them dominate the market," he notes. "They needed to change the rules, refocusing their business around service."

The central idea behind the company's brand positioning became "fresh." This originated with the product itself, but went deeper into the organization. Unlike most bottled water, which has a long shelf life, this company guaranteed it could get water out of the ground and delivered to the workplace within days. The "fresh" idea penetrated further by inspiring the organization to think of fresh approaches to everything they do.

"So this was not really a water cooler company," explains Markwick. "This was a service company that just happens to deal in water coolers. Their aspiration was to be mentioned in the same breath as companies like FedEx."

To demonstrate the idea of fresh, Wolff Olins helped the company identify a wide range of improvements that would make the service they offer the best in the business. More importantly, these changes would help make customers' lives easier. For example, the company established a policy that, between 7 a.m. and 7 p.m., a person, not a machine, would answer customer phone calls. They produced large water bottles with handles to make them easier for customers to replace, supplied free bottle racks, and introduced late-night loading to speed up delivery. Equally important, Wolff Olins worked with every company employee to determine how their jobs could be made fresher.

Talking Water

As it explored names and visual directions for the new company, Wolff Olins began to develop a concept that focused on the role of the water cooler as an office meeting place. They were inspired by the classic Hollywood water cooler scene, which depicts workers talking while they fill their paper cones with water.

"If you create environments within an office space where people can talk and really communicate, you're bound to foster new ideas and ultimately make the company more effective," notes Markwick. "Water coolers can provide a place like that. But it meant redesigning them so that they fit modern office environments and weren't hidden away."

This notion of "talking water" led the Wolff Olins team to the company's new name: Powwow. "There's an element of conversation around the word, and it's distinct enough to set itself apart from all the water companies that include 'spring' in their names," Markwick adds. "It also needed to be abstract and unlimiting, so that the company could grow itself into a major service brand."

Conversation Piece

To inspire emotion in its customers, the brand needed to establish an ongoing dialogue with them. So while the Wolff Olins team experimented with possible brand marks and a visual vocabulary, they also began developing a tone of voice unique to Powwow. The resulting attitude is friendly, playful, and often irreverent, "looking to shake things up a bit," as Markwick describes it. Snippets of conversation, always humorous, appear with the Powwow name virtually wherever it goes, from job applications to delivery vehicles. Water coolers, for example, bore this message for a while: "The Powwow customer service line is open from 7 a.m. to 7 p.m. So pick up the phone and chat to us. We're happy to talk about anything, but our real strength is water coolers, definitely."

"It's a bit lighthearted, and fun," says Markwick. "The intention is that people will want to come back for more of it."

[above] *The design team also explored a range of color palettes. Since greens and blues are used by many other water suppliers, they were ultimately avoided.*

[below—left] *The final solution is simple but eloquent, rendered in hand-drawn letters with distinctive, rounded forms. The use of pink and purple is unique in Powwow's business sector.*

[below—right] *The logotype can also be stacked. It appears in various combinations of pink, purple, and white or black and white, depending on the application.*

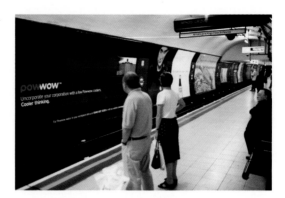

[above—left] *Powwow gave away bottles of its water as part of a launch advertising campaign in early summer 2000.*

[above—right] *Transit advertising in London's tube system was also part of the launch campaign. In the subway tunnels, commuters were introduced to Powwow's "cooler thinking" voice, which uses humor to inspire interest in the product.*

[above—lower left] *Trucks serve as moving billboards for the new company. All company vehicles feature the new identity and Powwow's signature humor.*

[above—lower right] *The company's Web site and screen savers were also part of the project.*

[right] *Even job application forms and letterhead carry snippets of "cooler thinking."*

The accompanying logotype is simple and straightforward, a custom, hand-drawn typographic treatment that features the Powwow name in combinations of pink, purple, and white. "We determined early on that a typographic treatment would be the best solution," says Markwick. "Powwow is very distinctive. You don't need to try too hard when you have a name that distinctive." The team chose pink and purple to differentiate Powwow from the many water companies who use greens and blues in their identities.

Wolff Olins translated the new brand to a wide range of applications, including stationery, delivery vehicles, marketing collateral, uniforms, signage, Web site, screen savers, and a brand book. They also created an advertising campaign that debuted in London just before the launch.

But Powwow really expressed the core of its brand when it redesigned its water coolers to reinforce the customer-service promise. The coolers employ state-of-the-art technology to make life easier for all who use them. For example, higher taps mean no bending to get a cup of water. Larger cups mean fewer trips to the

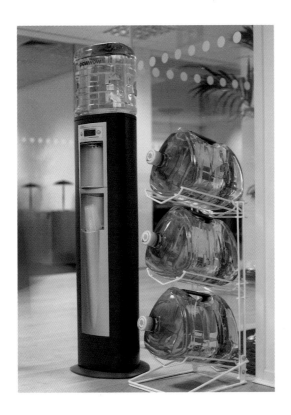

[left] *Powwow expressed the core of its brand when it redesigned water coolers to reinforce the customer-service promise. The new coolers are attractive and much more user-friendly than traditional coolers.*

[below] *Wolff Olins designed a brand book that uses Powwow's "cooler thinking" as a central theme and outlines the company's guiding principles of freshness. The book was distributed to employees and business-to-business clients.*

cooler, while a low-cups indicator warns when cups are running out. A new evaporation system means the drip tray is practically self-emptying. And the design is very attractive, not an eyesore to be tucked into a far corner.

Refreshing Results

The Powwow brand has been well received by its customers, and business has increased dramatically since the brand was introduced. In 1999, the market share of the newly acquired companies (combined) was 18.6 percent. By November 2000, Powwow's market share was 27 percent, and rising. Crystal Spring was the only one of the former companies with a Web site, and it averaged 323 hits per day. Powwow's Web site receives an average of 1,641 hits per day.

"It's impossible to say whether these increases are a result of the new brand platform, the company's new approach to doing business, or a combination of many factors," Markwick states. "But the point is, Powwow has become a brand that's not only about a fresh product, but about a fresh way of doing business. People respond to that inside and outside the company." ■

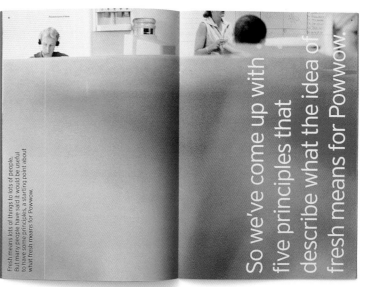

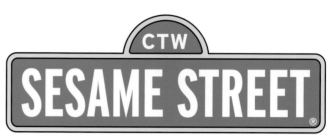

CHILDREN'S TELEVISION WORKSHOP

Sesame Workshop

Children's Television Workshop keeps its Sesame Street address, but moves forward with a big new identity.

When your address is Sesame Street, your front man is Big Bird, and your name is synonymous with quality television programming for young children, brand image shouldn't be a problem. But after thirty-one years as Children's Television Workshop, the New York-based not-for-profit organization found that the institutional nature of its name had become a liability.

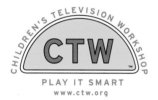

PLAY IT SMART
www.ctw.org

[top] *Sesame Street, a cultural touchstone and one of the world's most powerful brands, was a key element of Children's Television Workshop's brand promise.*

[above] *The institutional connotation of the Children's Television Workshop name had become a liability. Shortening its name to CTW met with little success, as its audiences did not recognize it.*

Research showed that for those who recognized the name, Children's Television Workshop (CTW) was virtually interchangeable with public television and other brands that produce children's programming. And since the name was grounded in television, it seemed limiting to an organization that was also involved in the Internet, interactive games, books, CD-ROMs, and other media geared toward children.

CTW's executive team also realized the organization needed to function as a brand, with a name and brand promise that speaks clearly to its audiences, including children, parents, and business partners. They commissioned the Carbone Smolan Agency (New York City) to help them articulate and express that promise.

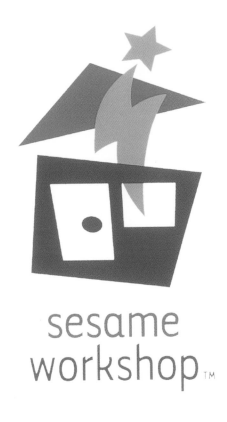

sesame
workshop™

Client: Sesame Workshop, New York City

Sherrie Rollins Westin	executive vice president, marketing, communications and research
Anna Maria Cugliari	senior vice president, strategic marketing and brand management
Suzanne Duncan	vice president, advertising and creative services
Heather Imboden	director of advertising and marketing services

Design Team: Carbone Smolan Agency, New York City

Ken Carbone	cofounder and executive creative director
Justin Peters	design director
Tom Sopkovich	designer
Jennifer Greenstein	project manager

[above] *The final mark suggests that learning, and fun, happen here. Carbone Smolan chose a palette of bright primary colors and paired the mark with the company name in a classic but whimsical typeface called Tarzana Narrow.*

SesameWorkshop

A Global Brand

CTW had already begun the re-naming process when the Carbone Smolan Agency was brought on board, so its executive team had defined key brand attributes and the message they wanted to send to their audiences.

CTW knew that it needed to capitalize on the Sesame Street brand, which had become a cultural touchstone synonymous with a dedication to children, education, and fun. So the names on its list of possibilities included monikers like Sesame & Co., Sesame Unlimited, and Sesame Workshop. When the Carbone Smolan Agency reviewed the options, they felt strongly that Sesame Workshop was the best candidate. "It really gave them a kind of bookend opportunity, because it leverages the jewel of their brand, Sesame Street, and also recalls the proud heritage of Children's Television Workshop," says Ken Carbone, cofounder and executive creative director for the agency.

More important, Carbone Smolan and CTW agreed, was that the word "workshop" suggests a destination, a creative place where people come together to invent and explore in pursuit of a common goal. It connotes a stimulating, active environment and created the perfect branding platform for the organization.

A Creative Mark

Once the name was established, the Carbone Smolan Agency needed to move quickly to show the organization's board a visual representation of the new name, which they were to vote on. To start the process, the agency explored logotypes, and actually presented a simple, colorful logotype to the board when it introduced the new name.

[above] *The design exploratory started with logotype sketches. Carbone Smolan attempted to ornament the letterforms to capture the essence of the name, but soon realized a logotype alone would not be "embraceable" enough for small children.*

[above—right] *The new name (shown in a preliminary logotype) leverages the strength of the Sesame Street brand and recalls the heritage of the Children's Television Workshop. The word "workshop" implies a destination where creativity, exploration, and fun happen.*

But the designers immediately realized that just a logotype would not be "embraceable" enough for children who don't yet read, notes Carbone. "We did an exploratory of just logotypes, trying to see how playful we could be with the name by ornamenting the letterforms. But ultimately we couldn't go far enough with the logotype and pushed on toward symbols."

The team experimented with many symbols that would encapsulate the childlike wonder, love for learning, and trust embodied in the Sesame Workshop name, but a simple, colorful drawing of a house "exploding" with creativity and fun hit the mark. "It literally speaks to the idea of going some place where creativity and learning are happening," explains Carbone. After some refinements to the house's colors and graphic elements, Sesame Workshop had its new symbol.

Bringing it to Life

Given the wide range of media that Sesame Workshop is involved with, the mark had to translate well in print, on television, on the Web, and in animation. The house mark—with its simplistic styling, separate graphic elements, and colorful palette—fit the bill.

To add versatility, the Carbone Smolan Agency developed four color palettes that can be used interchangeably. It paired the symbol with the Sesame Workshop name in Tarzana Narrow, a typeface that Carbone says combines the clarity of classic faces like Univers or Helvetica with a little playfulness. "There's a hint of whimsy, but it's not condescending like some 'kid' typefaces are," he relates.

[opposite page—bottom]
Symbol explorations focused on expressing the childlike wonder, love for learning, and trust implicit in the Sesame Workshop brand. Spaceships, globes, robots, and other symbols were explored before designers arrived at a house "exploding" with creativity and fun.

[left] *Designers played with colors, graphic elements, and angles during refinement of the house symbol.*

[top right] *Sesame Workshop's paperware includes the symbol in different color variations, reinforcing the concept of creativity and exploration.*

[top left] *A key deliverable was the "thanks" book designed for Sesame Workshop employees and close business partners. The wire-bound handbook introduced the new name, explained the logic behind it, and encouraged employee support.*

[bottom right] *A press kit included an announcement card and a special premium, a color-in logo t-shirt and markers.*

[bottom left] *For a television industry trade show in Cannes, France, Sesame Workshop developed marketing materials for individual properties and gave away customized "Big Bird Watching" binoculars.*

After applying the identity to Sesame Workshop's paperware system, Carbone Smolan developed one of the project's most significant deliverables, a "thanks" handbook that introduced the new identity to employees and business partners. "This was a very important piece, because it explained the logic behind the change and also articulated Sesame Workshop's mission and brand message," notes Carbone. "It went a long way toward achieving 100 percent buy-in of the new identity."

The mark was applied to Sesame Workshop's Web site and the Carbone Smolan Agency worked with a team of animators to bring the symbol to life, literally, for television programs. Other deliverables include a style guide, print advertising, and Sesame Workshop's booth at a television industry tradeshow in Cannes, France.

A Success Story

The new identity has been met with applause from both employees and business partners, says Carbone. "Not only is there 100 percent buy-in internally, culturally it has given Sesame Workshop something they feel really good about promoting. They've all embraced this as a flag they can wave."

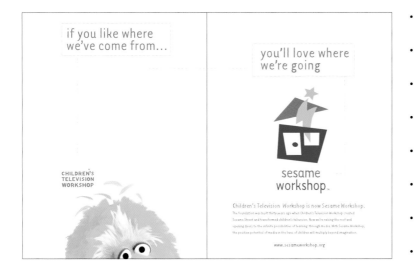

[above] The home page of
www.sesameworkshop.org
leverages its most familiar
properties, but also features the
new identity and borrows its
bright color palette.

[left—top] Advertising spreads
announced the new identity
using a recognizable Sesame
Street icon.

[left] The Sesame Workshop style
manual is a comprehensive guide
to the brand, from editorial voice
to brand architecture and color
palettes.

Since the new identity was adopted, Sesame Workshop has also been success-ful in securing new business relationships with co-sponsors for programming and other initiatives. Carbone attributes this, at least partially, to the new iden-tity. "When a not-for-profit reenergizes itself by taking on a project like this, it establishes a certain level of credibility," he notes. "It tells prospective busi-ness partners that this is a high quality, forward-thinking organization." ■

Sun Microsystems Inc.

A global computing leader clarifies its brand message to reinforce the Internet connection.

Incorporated in 1982, Sun Microsystems Inc. has been a prolific developer of network computing solutions and a pioneer in burgeoning Internet applications. It used the Internet for company communications long before the "information highway" became a household word, and has created many of the platforms that make Internet use possible. Sun felt it had earned the right to proclaim (as does its advertising slogan), "We put the dot in dot.com."

But due to aggressive marketing by its Silicon Valley competitors, and its own tendency to focus on promoting individual sub-brands or products rather than promoting a unified corporate identity, Sun felt it was not getting the credit it deserved as a market and technology leader. In 1999, the company decided to reexamine its brand strategy with an eye toward enlightening the public about its major role as an Internet enabler and technology leader.

Sun called on Addwater (San Francisco) to help clarify its brand message by developing a "toolbox" of design elements that would visually link Sun and its family of products. The new system needed to leverage Sun's dot-com advertising slogan and subtly educate consumers and business partners about Sun's products and market leadership.

"Sun had begun to realize that a more consumer-based marketing approach could benefit them, and they wished to better connect with that audience,"

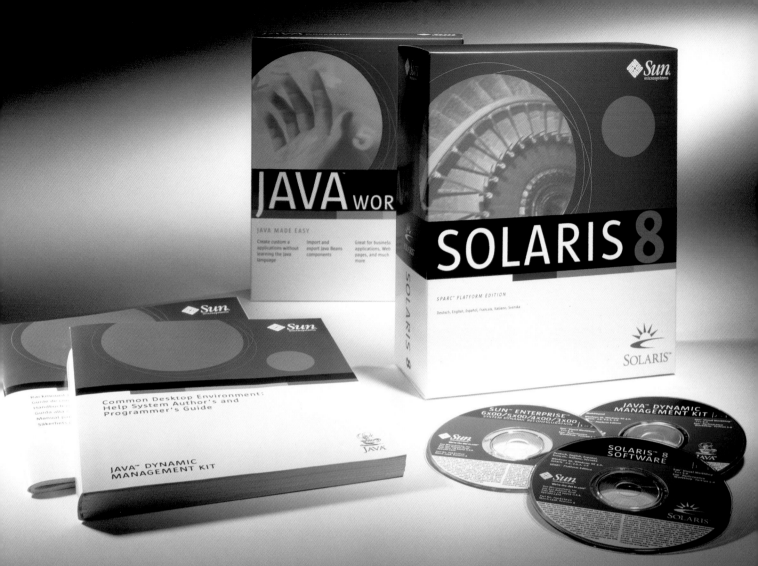

Client: Sun Microsystems Inc., Palo Alto, California

Steve Gibson	director of creative services
Noel Lopez	manager, design communications
Chris Haaga	manager, design communications
Mark Paisley	director of investor relations (annual report)
Al Riske	copywriter (annual report)
Susan Sano	project manager (annual report)

Design Team: Addwater, San Francisco

Rob Gemmell	creative director
Betty Lin	associate creative director
David Albertson	art director (annual report)
Kristie Koehler	senior designer
Leif Arneson	senior designer
Iris Greiner	designer
John Ravitch	account manager
Max Beck	project manager

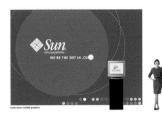

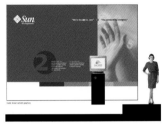

[above] *Brand explorations focused on the existing condition and three concepts, each a more provocative, enhanced version of Sun's existing identity. Addwater developed a visual vocabulary, toolbox, and guidelines for each option, then simulated how they would look on packaging, smart cards, support cards, and trade-show exhibits.*

notes Rob Gemmell, Addwater principal and creative director on the project. "Our goal was to reinforce Sun's leadership by graphically connecting Internet-like imagery with Sun in a unique and memorable way, then streamline it so it could be easily deployed worldwide."

Sun did not want to change its existing corporate logo, a cube formed by the letters in the Sun name. But it did want Addwater to unify the brand by creating a new visual language—a collection of colors, graphic symbols and images, type fonts, and other elements—to apply to packaging, user publications, and other materials.

Getting Started

- The Addwater team started the process with Sun's in-house team by examining Sun's branding strategies and establishing the philosophical underpinnings of the new program. The strategic phase began with several meetings with the Sun team, and included interviews with executives and Sun's advertising agency.

- Addwater also immersed itself briefly in the technical aspects of packaging and publication specifications so that designers would be aware of any technical limitations on the new system. An audit of existing marketing materials and packaging dramatically underscored Sun's lack of a unified identity, says

Gemmell. "They hadn't established a unique and ownable look and feel so there were lots of ways to interpret the Sun look. You could see a lot of their marketing and packaging materials and not realize they were for Sun."

As brand explorations began, Addwater's designers isolated the most effective marketing pieces and identified the graphic elements that seemed to resonate. These elements were incorporated into visual explorations, which were quickly pared down to four approaches. Beginning with a "cleaned-up" version of the existing system, each solution explored a progressively more provocative visual expression of the brand. For each approach, Addwater developed a visual vocabulary, guidelines, and toolbox, then simulated how they would translate into brochures, packaging, tradeshow exhibits, and even smartcards.

[left] *(Before) Graphic treatments used for Sun products varied as widely as the products themselves. The company's marketing efforts had focused more on sub-brands or individual products than on creating a consistent, recognizable corporate identity.*

[below] *Packaging and user materials for Sun's Star Office products were the first to be launched in the new brand identity program. Shapes and images used on product packaging are subtle references to the Internet and Sun's leadership role in its evolution.*

[above] *Sun had already launched its successful "We put the dot in dot.com" advertising campaign, and wanted the new graphic system to leverage it. To support the positioning, Addwater created a brand brochure that introduced some of the new graphic elements, including the "Sun blue" color and the unifying black bands and color bars.*

[right—top] *Sun's approach to user guides is a bit unusual. The printed versions have a digested, USA Today feel to them, and direct users to the Sun Web site for more detailed information. Sun's clean new typeface, judicious use of white space, and consistent use of its new color palette go a long way toward making the guides look readable and interesting.*

[right—bottom] *In 1999, there was so much good news to report about Sun that it opted for a newspaper-style format for its annual report. Based on a concept by cofounder and chairman Scott McNeeley and director of creative services Steve Gibson, Addwater simulated the overall look of The Wall Street Journal, but modified typefaces, spacing, column widths, and other details.*

The Sun Solution

Sun's team ultimately chose a fairly close-in approach that streamlines the existing system and adds memorable elements to it. The new "toolbox" contains several visual devices that combine to create a unique and "ownable" look for Sun, says Gemmell.

The graphic system's primary unifying element is bold color, a deep violet blue that is distinctive and also difficult to reproduce accurately (and therefore harder for competitors to copy). Used only minimally in the past, "Sun blue" is now dominant in packaging and user materials. A supporting palette of yellows, reds, and oranges adds warmth.

Another prominent feature is the use of black bands with white type reversed out of them. Designed to command attention and convey the importance of the message within, the bands are reserved for product identification and major brand messages only. Color bars beneath them add interest and abstractly represent the dynamics of electronic data transfer.

A clean new typeface developed by Sun's creative services department adds a contemporary look to the system. The system's linear elements are offset by the use of circles that contain imagery either depicting the product itself or repre-

senting the benefits of using the product. Light, off-center lines that surround the circles add a feeling of movement and provide shelf appeal to packaging.

Together, these elements create a distinctive, unified look for Sun's packaging and communications materials, says Gemmell. "The goal is for customers to see a Sun product or brochure and instantly recognize it, even if there wasn't a logo on it."

Consistency Guarantee

The new graphic system was applied to all of Sun's product launch collateral materials, hardware and software packaging, user publications, and its annual report. It's also been applied to tradeshow exhibits and event marketing graphics, as well as multimedia tools such as presentation templates, software splash screens, and Web page templates. Sun's Web site was redesigned to incorporate the new program so that all touchpoints between Sun, its customers, and partners convey a consistent look and feel.

Since much of Sun's graphic design work is outsourced, the company needed a detailed style guide to ensure that the toolbox elements are applied consistently by the many designers involved with Sun materials. Addwater published a style guide in a wirebound book and also posted it on Sun's community intranet. Downloadable templates help discourage non-approved applications of the elements, says Gemmell. "Steve Gibson, Sun's director of creative services, convinced upper management to take on this project because his staff was spending too much time policing agencies and in-house staff on how to consistently communicate the Sun brand," he adds. "They wanted this system to be foolproof and crystal clear, so there's no question about how to communicate the brand." ∎

[top left & right] Sun's twelve-page style guide outlines how the new graphic elements should, and in some cases, should not, be used. The guide is also posted on Sun's community intranet (right). Downloadable templates help ensure that the many designers involved with the Sun brand translate it consistently.

[above—bottom] Sun's Web site is a major component of its marketing approach. To make sure that all touchpoints between Sun, its customers, and its partners communicate the same brand message, Sun redesigned the site to mirror the look and feel of the new graphic toolbox elements.

FUELING GROWTH IDENTITY FOR GROWTH

Mergers and acquisitions, IPOs, and rollouts are now part of our daily vocabularies. But behind the scenes of the business headlines, how do large corporations manage the changes brought by growth, consolidation, and other market changes?

Many use new brand identities to stay connected with their local and global audiences. These companies recognize that a cohesive brand platform, consistent messaging, and strong visual imagery are essential to their bottom lines.

After merging with Amoco and acquiring ARCO and Castrol, BP is now the third largest oil company in the world, with more than 100,000 employees and 29,000 retail outlets around the globe. BP needed a strong new identity to unify the four previously independent companies and symbolize its values. After exhaustive market research, BP adopted its bold new "helios" symbol, which communicates BP's environmental leadership, its performance orientation, and its aspiration to move beyond the petroleum sector and become one of the world's great brands.

When Canadian paper manufacturing rivals Abitibi-Price and Stone-Consolidated Corp. merged in 1997, they formed a huge company that employs 18,000 people in twenty-nine mills around the world. The "merger of equals" demanded an identity that would harmoniously blend the two companies' distinct cultures and reflect their common mission to become a world leader in the paper industry.

BuildNet set out to revolutionize the building industry by providing project management resources at all points in the supply chain. Boosted by venture capital investments, it rapidly acquired several competitive software companies. In its fast-growth mode, BuildNet needed to bolster its own corporate identity while temporarily maintaining the product identities already established by its newly acquired companies. The solution was a flexible brand architecture system that allowed BuildNet to optimize the equities in its acquired products while establishing a monolithic brand identity for the long term.

Also in this section: Global express carrier TNT and Puerto Rican bank chain Westernbank.

ABITIBI-PRICE INC.

Stone-Consolidated
Corporation

Abitibi-Consolidated Inc.

Two Canadian paper manufacturers merge cultures and identities.

When paper manufacturing rivals Abitibi-Price and Stone-Consolidated merged in May 1997, their union was one of the largest corporate mergers in Canadian history. Today, Abitibi-Consolidated employs 18,000 people in twenty-nine paper mills across Canada, Europe, and the United States.

[above] *(Before) In one of the largest corporate mergers in Canadian history, paper manufacturing rivals Abitibi-Price and Stone-Consolidated Inc. united two vastly different corporate cultures. The newly formed company needed a strong new identity to communicate its leadership mission.*

The heads of the two companies, co-chairmen Ron Oberlander and Jim Doughan, shared a vision of establishing Abitibi-Consolidated as "the world's preferred marketer and manufacturer of papers for communications." But while the two companies' markets and business objectives were similar, they differed dramatically in organizational style and culture. As a "merger of equals," the newly formed company needed to meld the two distinct cultures into one harmonious unit. And its new name and corporate identity needed to reflect the common vision and position the company as a global leader in the highly competitive paper industry.

Karo (Toronto) Inc. was chosen to design a new brand mark and visual identity system that would help propel Abitibi-Consolidated into the forefront of its industry. The project scope included a wide range of applications, from stationery to vehicle graphics and from packaging and posters to brochures and giveaways.

Karo's role extended beyond the traditional range of identity design to actually helping shape the new company, says Stewart Howden, the firm's president and project leader. The Karo team organized and facilitated a series of "vision and values" workshops with company executives, management, employees,

ABITIBI CONSOLIDATED

[left] *The new identity, a globe-shaped, spiraling roll of paper, symbolizes Abitibi-Consolidated's leadership in the paper industry, as well as its emerging global presence.*

[below] *Abitibi-Consolidated's bold corporate mark, shown here on stationery, sets it apart from paper-industry competitors that tend to overuse tree-and-forest imagery to communicate environmental friendliness.*

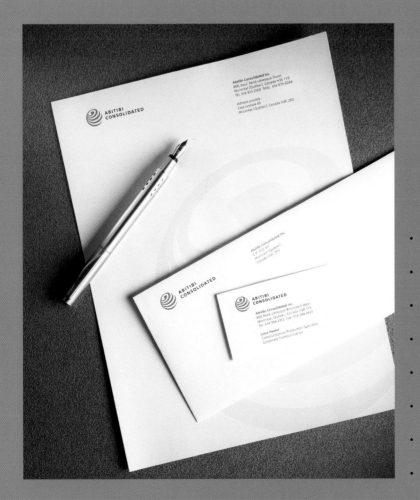

Client: Abitibi-Consolidated Inc., Montreal

James Doughan	president and ceo
Ronald Oberlander	operating chairman
Susan Rogers	vice president, corporate communications

Design Team: Karo (Toronto) Inc., Toronto

Stewart Howden	president and coo
Paul Browning	executive vice president, creative director
Philip Unger	design director
Kerry Fenech	executive assistant
Iwona Sowinski	senior designer
Jim Muir	production artist
Scott Jarvis	production artist

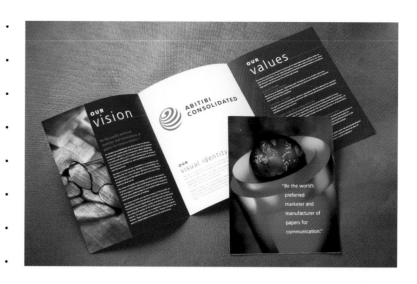

[above] *Employee "sell in" was a key component of the project. Karo created a series of posters that were displayed in paper mills to communicate the company's key values.*

[right—top] *One of the first products Karo created was a "vision" brochure distributed to the client's 18,000 employees worldwide. Its cover features a photographic treatment of the logo symbol.*

[right—middle & bottom] *The visual identity system was developed in both French and English, and included a wide range of publications and brochures.*

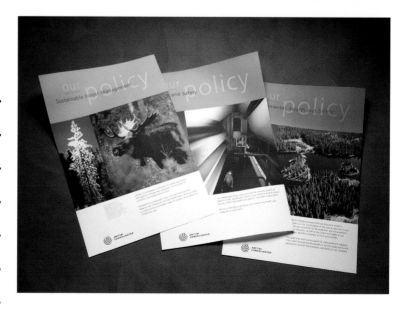

customers, and strategic partners, and helped develop a critical-path transition to ensure a timely, seamless launch and implementation of the new identity. "Being involved in the birth of this new company provided us with invaluable insight into the new brand and how its identity should communicate within the marketplace," Howden notes.

A New Face

First and foremost, Abitibi-Consolidated needed a strong brand mark that would serve as its new public "face." Immediately following the merger, the Karo team developed a simple interim logotype that both partners could use to represent the newly formed company until its new name and visual identity were publicly launched. Well informed by its leadership in the "vision and values" workshops, Karo also began design explorations for a new logo/mark, using Oberlander and Doughan's shared vision as their springboard.

The final solution is a globe-shaped, spiraling roll of paper that symbolizes Abitibi-Consolidated's emerging global presence and leadership in paper manufacturing and marketing. Resisting the paper industry's tendency to overuse tree-and-forest imagery, Karo's design team created a mark that visually captures the company's brand positioning in a bold, concise way. Designers chose a strong, bright red for the symbol and paired it with dark blue for the company name, which is rendered in the classic Frutiger typeface.

Abitibi-Consolidated

[above] *Immediately after the merger, Karo (Toronto) Inc. created a simple interim logo that both partners could use until the new identity was launched.*

[below] *The visual system also includes ten different signage types, including a corporate emblem mounted in the reception area of the Montreal headquarters.*

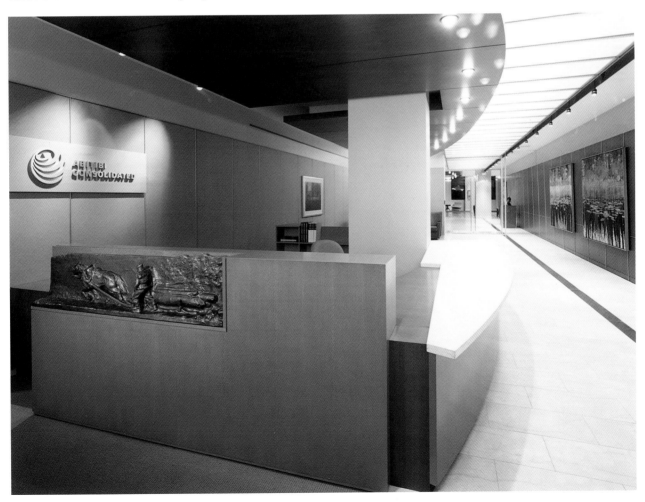

[right] *The new identity was applied across a wide range of items, from a company directory, to mouse pads, and even hard hats.*

Paul Browning, Karo's executive vice president and creative director, says that while the identity was designed around the combined company name, it needed to be flexible enough to transition to one name in the future, which was Karo's recommendation. "Management felt that the combined name at this stage would contribute to the notion of a 'merger of equals,' at least optically, but there was general consensus that it would move to simply 'Abitibi' in the future."

Supporting Cast

Because of the sheer scope of the project, the new visual system (developed in both French and English) was phased in gradually following a critical-path process outlined by the Karo team. First on the agenda were promotional materials to educate Abitibi-Consolidated employees about the merger, the new identity, and most important, the new company's vision and values.

In tandem with stationery and other business papers the company needed immediately, Karo created a set of seven full-color corporate branding posters and an employee launch brochure to summarize the new identity. The posters were displayed in the paper mills to provide a backdrop for a carefully orchestrated roadshow by Oberlander and Doughan, who personally introduced the new identity and the company's vision and values to employees. The Karo designers also developed a four-volume set of "Visual Identity Guidelines" that addressed applications needed for more than forty-five company locations worldwide.

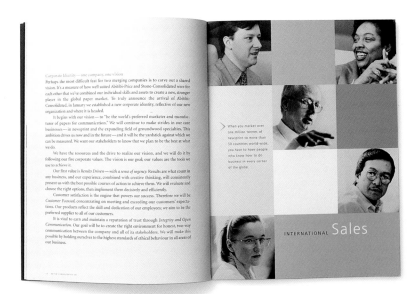

The team also created a signage system that incorporated ten different sign types. To simplify production and help ensure the signs were implemented effectively, Karo developed a library of more than eighty informational and safety icons. Other applications included uniforms and vehicle graphics, packaging, exhibits, publications, and Abitibi-Consolidated's first annual report after the merger. Karo also designed the company's first "Environment, Health and Safety Report," a 28-page, full-color brochure and companion pieces including posters and a set of fold-out brochures.

Abitibi-Consolidated has achieved its goal of forming the world's largest manufacturer of newsprint and uncoated groundwood papers. In 1997, its assets totaled $6.3 billion and synergies resulting from the merger represented $200 million in savings during the first year. With the help of a well-planned transition and a solid, new visual identity, say Howden and Browning, "The company has been able to realize its stated business goals, transforming two entities into one and creating a truly global brand." ∎

[above] *The 1997 annual report used the tagline "One Company, One Vision" to communicate the integration created by the merger.*

[left] *Livery graphics feature the bold red symbol on a dark blue background.*

*BP*Amoco

BP | # The world's third largest oil company brands itself to move beyond the petroleum sector.

Oil giants British Petroleum (BP) and Amoco merged in 1998 to form BP Amoco. When BP Amoco acquired ARCO in 1999 and Castrol in 2000, the result was a Fortune 10 company with more than 100,000 employees, 29,000 retail outlets, and wide-ranging oil and gas, petrochemical, and energy operations worldwide.

[above] *(Before) The new oil company formed by British Petroleum, Amoco, ARCO, and Castrol has 100,000 employees and 29,000 service stations worldwide. The new company needed a strong, monolithic brand identity to communicate its goal of moving beyond the petroleum sector.*

[opposite page] *The new BP Connect service station format is perhaps the highest-profile application of the new identity. With more than 29,000 stations worldwide, BP has more retail sites than McDonalds.*

To help propel itself forward in the marketplace, the new alliance needed a strong brand identity to unify the four previously independent companies and communicate its vision for the future. The identity needed to symbolize the dynamic new organization and reflect the values to which it aspires: performance, environmental leadership, innovation, and progressive ideas. And perhaps most important, the identity needed to help the company communicate that it is more than an oil company and that its aspiration is to move beyond the petroleum sector to become one of the world's great brands.

"We're not just an oil company," says Stephen Williams, BP's vice president of strategic marketing. "Yes, we're about exploration and production and all that being an oil company implies. But we're also about solar energy, clean fuels, and being a positive force in the communities where we do business and where our people live."

In May 1999, the company called on Landor (San Francisco) to develop the new identity, including a name and brand mark that would signal to the world that BP is not going about "business as usual."

Client: BP, London

Sir John Browne	group chief executive
Lee Edwards	vice president of brand
Stephen Williams	vice president of strategic marketing
Anna Catalano	group vice president of marketing

Design Team: Landor, San Francisco

Margaret Youngblood	creative director
Nancy Hoefig	creative director
Courtney Reeser	creative director
Peter Harleman	senior brand strategist
David Zapata	design director, environments
Brad Scott	design director, interactive
Cynthia Murnane	senior designer
Todd True	senior designer
Frank Mueller	senior designer
Ivan Thelin	senior designer
Ladd Woodland	senior designer
Kistina Wong	senior designer
Michele Berry	designer
Maria Wenzel	designer
Jane Bailey	writer
Susan Manning	writer
Wendy Gold	account director, interactive
Greg Barnell	project management
Stephen Lapaz	project management
Bryan Vincent	project management
Russell DeHaven	realization

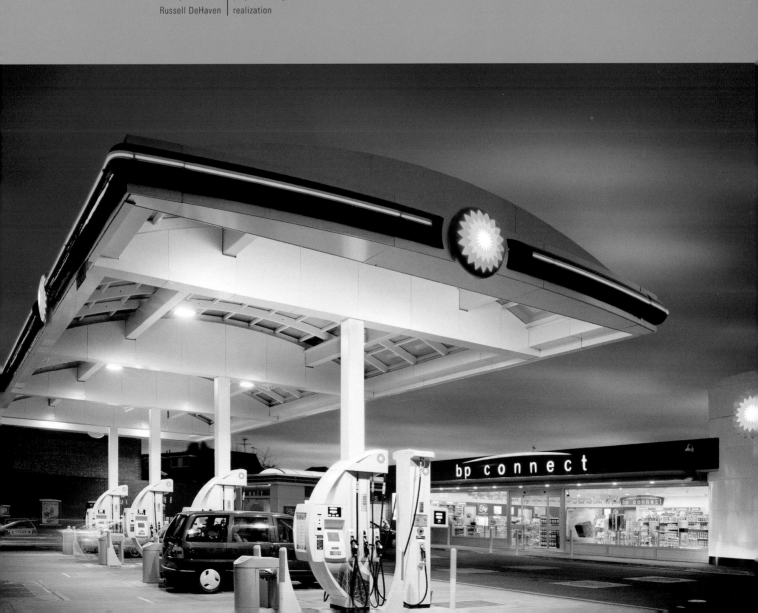

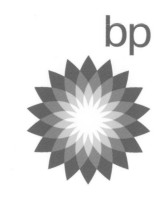 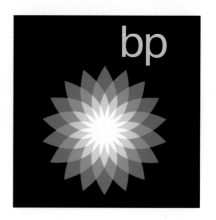

[above] *(Before) While BP's green-and-yellow color palette was considered a brand asset worth retaining, the shield, which represented protection and stability, was not considered appropriate for the new company. A dramatically new mark would best herald BP's embrace of change and its movement beyond the petroleum sector.*

[above—middle] *With its interlocking planes and colors, the new Helios mark symbolizes the sun, energy, and BP's commitment to environmental leadership. Unorthodox for an oil company, it tells the world that BP is not going about business as usual.*

[above—right] *The new symbol was designed to work equally well on light as well as dark backgrounds. It translates easily to a wide range of applications, including animation.*

A New Name

Landor began the process by analyzing a large body of industry research that had been commissioned by BP. Using Landor's internal research model, the team also audited competitors' identities and evaluated BP and Amoco's brand assets. The goal, says Susan Nelson, Landor's research director, was to gain an understanding of the gas/petroleum industry and the new company's place in it.

"On the whole, the industry is undifferentiated," says Nelson. "That means that the consumer sees all the brands as pretty much the same—almost as commodities." While the research showed that Amoco was more established as a brand in the U.S. than BP, it was less differentiated than BP, which was seen as "up and coming." Landor concluded that neither the BP shield nor the Amoco torch-and-oval brand mark were appropriate to represent the new company and its goals.

In July 1999, based on the research and several rounds of interviews with BP's executive board, Landor recommended the new company be renamed BP. "BP is a simple, straightforward name that is easy to remember," says Margaret Youngblood, Landor's creative director for corporate identity. "Above all, it stands for the new company's aspirations: big picture, bold people, better products, beyond petroleum."

To Williams, the name respects a rich heritage and promises a bright future. "We considered a lot of names, many of them combinations of the individual companies that make up the new BP. We thought that the letters BP formed a name we could extend around the world. It speaks to our heritage, but really allows space for our future possibilities."

A New Mark

Landor entered the creative phase of the project with a wide-ranging exploration of possible brand marks, but soon narrowed its focus to two concepts: creative manipulation of the "B" and "P" letterforms, and exploration of natural geometric forms that reinforced BP's environmental commitment. Research showed that the BP color palette of green and yellow was unique in the petroleum sector and identified it as an important brand asset to retain.

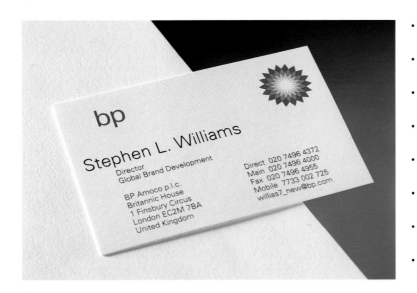

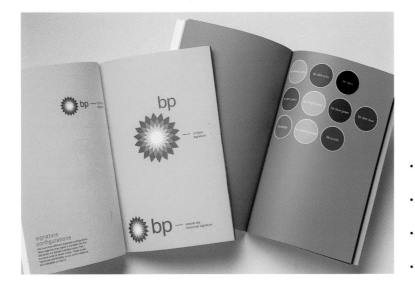

[left—top] *The identity system can be used dynamically by breaking apart the BP logotype and the Helios mark. The employee name beneath the corporate logotype is a metaphor for the direct relationship between individual and corporation, an important part of the BP corporate culture.*

[left—middle] *The Landor team designed a set of three perfect-bound launch books that were encased in a hard slip case. They included an identity book, a brand book, and a company policy book. Sets were given to top executives and individual books were given to employees.*

[left—bottom] *Spreads from the BP Identity Book show color palettes and various applications of the brand mark.*

[right] *The Brand Book, part of a set of three books given to employees on launch day, uses photographic metaphors to express the attributes of the new company. Explaining the ideas behind the new identity to BP's 100,000 employees was an important part of the project.*

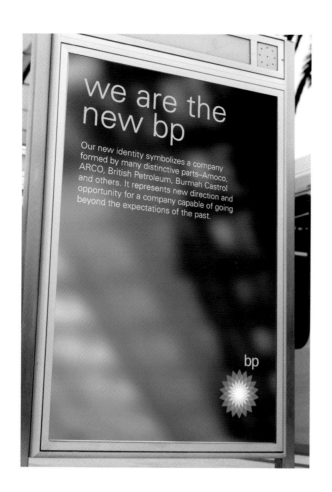

Working with the BP executive board, Landor presented possible brand marks in a range of simulated applications so they could see how the mark would look in the real world, notes Youngblood. By October 1999, the team had two refined concepts to present to the BP board. Both were radically different from either the BP shield or the Amoco torch-and-oval, but one felt more comfortable in the world of petroleum and the other was a much bolder step away from the sector. Ultimately, Landor recommended the second option: the "Helios," a sunflower-shaped mark consisting of interlocking planes and colors.

"One of the key messages that BP wanted to communicate was their environmental leadership and focus on alternative energies, so our creative explorations lead us toward natural forms," says Youngblood. "The Helios mark reflects BP's determination to create products and services that respect human rights and the natural environment. It also represents the sun, a priority in BP's search for new sources of energy."

Before making its final decision, BP's executive board wanted to evaluate how the marks would look on their service stations, so they asked Landor to develop conceptual designs for a new retail format and simulate the marks on both. The Landor team developed a convenience store prototype design and also designed pylon signs, pumps, canopies, and car-wash units. By December 1999, the team was able to show how the two symbol options would look on the new service stations. The executive board almost unanimously preferred the Helios mark. A new symbol was born.

[above] *Merchandising was very important to BP as a way to show company pride. Many promotional items were designed and produced for the launch.*

[left] *Landor also designed a series of banners to promote the identity launch.*

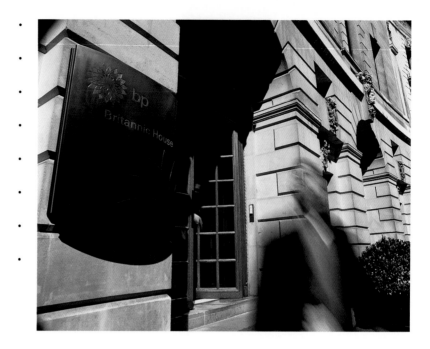

Bringing it to Life

[right] *A treated-copper sign outside Britannica House, BP's London headquarters, meets historical preservation standards while subtly signaling that changes are afoot.*

[below] *One of BP's most visible power applications, this design was one of several concepts produced for a new livery system.*

Landor paired the Helios mark with a lowercase logotype composed of custom-designed letters based on the Univers typeface. The choice of sans-serif letters gives it a clean, modern look, while the use of lowercase communicates that BP is friendly and approachable, says Youngblood.

In January 2000, Landor began media testing of the mark and proceeded with designing other elements of the identity system. The team chose color palettes, secondary graphic elements, designed a Helios "supergraphic" and applied the mark to business papers, corporate signage, presentation templates, and gift and merchandise items. The team also designed corporate interiors for BP's London headquarters, created branded PC desktop graphics such as screen savers, wallpaper and splash screens, and explored animation and branded sound. Print pieces, including a brand book, a policy book, and identity guidelines that were given to all 100,000 employees for the launch, were also part of the project.

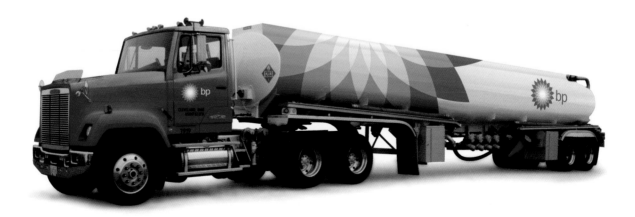

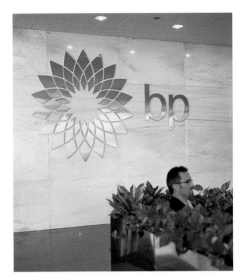

Application of the new identity to BP offices and facilities will be complete by the end of 2002, while the retail rollout will extend through 2004, says Williams. But the new identity means more than putting up a new sign or applying a logo to a truck, he adds. "For us it means making sure that every operation and everything we do moves us closer toward our aspirations. So any physical change is supported by a behavioral change within our company."

Perhaps more than anything, Williams adds, the new symbol is about change. "It helps us tell the story of a company that's about oil, but also about solar energy, clean fuels, and making our world a better place. It's also a symbol of energy. It's dynamic, it's bold, and it's something you wouldn't expect from an oil company. It's a tangible reminder of the progress and change we strive for every day." ∎

[above] *Landor also designed this metal signature inset in a marble wall at corporate headquarters. Also at headquarters, an abstract sculpture representing the Helios mark diffuses light and brings down the scale of the atrium space.*

[left—bottom] *Several screensavers were created and installed on employee computers for launch day. Landor's design team also designed wallpaper, splash screens, and a browser icon.*

F A S T

LLOYD'S

TOM Systems

TRUELINE SYSTEMS

BuildNet | # A builders' resource company constructs a living identity for growth.

In 1996, BuildNet Inc. quietly launched a revolution. Founded as a residential construction company in 1984, the former Sun Forest Inc. quickly moved into the realm of software development, recognizing an industry-wide need to streamline builders' back-office functions. By 1996, the newly renamed company had set its sights on the Internet. Its goal: to totally integrate the residential building industry by providing project management solutions at all points in the supply chain.

[above] *(Before) BuildNet had rapidly acquired five new software companies and already marketed its own software. Its new identity needed to unify all of the distinct product marks, position BuildNet as the flagbearer of the brand, and accommodate future acquisitions.*

Boosted by venture capital investments and alliances with major players in the building industry, BuildNet began acquiring competitive software companies whose products facilitate accounting, job costing, scheduling, estimating, and purchasing tasks for builders. It also established the BuildNet E-Building Exchange, which provides secure Internet-based procurement, e-commerce, and information services for homebuilders, suppliers, and manufacturers.

A Fragmented Identity

Rapid acquisition of five different software companies, and plans to purchase other businesses, fragmented BuildNet's original identity. BuildNet remained the parent company, but had allowed its acquired companies to continue using their own product identities. Presenting the BuildNet identity along with the logos of the acquired products created "visual chaos" and sent a confusing message to the marketplace, says Michael Bright, BuildNet's executive

BuildNet ®

SITETRAK
A BuildNet Solution

FAST
A BuildNet Solution

BUILDSOFT
A BuildNet Solution

LLOYD'S
A BuildNet Solution

TOMSYSTEMS
A BuildNet Solution

TRUELINE
A BuildNet Solution

Client: BuildNet Inc., Research Triangle Park, North Carolina
Keith Brown | chairman and founder
Michael Bright | executive director of marketing communications

Design Team: BrandEquity International, Newton, Massachusetts
Elinor Selame | president
Joseph Selame | creative director
Penelope M. Koukos | project manager
Theodore Selame | project manager
Juan Rivera | senior designer
Richard Hallam | senior designer

Consultant: ROI Marketing Communications, Raleigh, N.C.
Randy Drawas | principal

[above] *(After) To create a visual umbrella for the parent company and its sub-brands, BrandEquity tweaked the BuildNet typeface and replaced the partial circle around its "e" with an arc. The same arc enfolds simplified elements from the acquired companies' former identities, providing a transitional identity that helped maintain the companies' existing equity in their own market niches.*

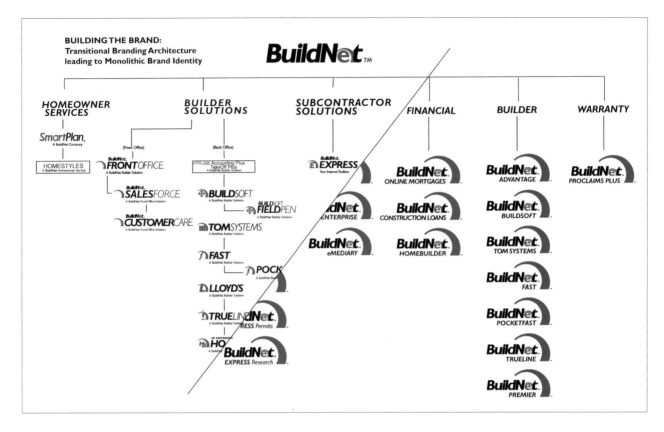

BUILDING THE BRAND:
Transitional Branding Architecture
leading to Monolithic Brand Identity

BuildNet ™

| HOMEOWNER SERVICES | BUILDER SOLUTIONS | SUBCONTRACTOR SOLUTIONS | FINANCIAL | BUILDER | WARRANTY |

[above] *BrandEquity developed a "living" brand architecture for BuildNet that can flex to accommodate the company's future acquisitions. When companies are initially acquired, a transitional identity incorporates the BuildNet "umbrella" over graphic elements from the acquired companies' former identities. Later, the old graphic elements are phased out and a monolithic system prevails, with the BuildNet umbrella as the most prominent feature.*

[right] *An introductory brochure plays on the shape of the umbrella-like arc in the new BuildNet logo. It will become increasingly prominent as the company's brand flagbearer.*

director of marketing communications. As BuildNet prepared to launch its new concept at the January 2000 National Association of Homebuilders show, Bright knew they needed to present a strong, unified image to the industry.

"We were a newly created company in search of a way to clarify ourselves to our market," says Bright. "We needed to make it easier for people to understand what we were doing: creating a family of solutions to meet the needs of every size builder."

On recommendation from its marketing consultant, BuildNet called on BrandEquity International (Newton, Massachusetts) to create a new branding strategy that would not only make a strong impact at the tradeshow, but grow with BuildNet as it acquired new companies.

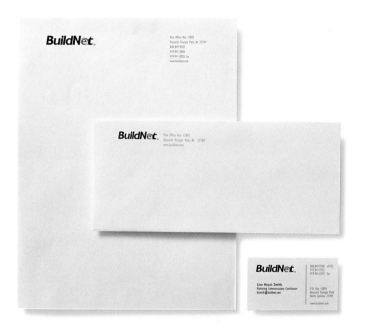

Flexibility for Growth

"This company was making radical changes in their industry, and we realized they would be in a growth-and-acquisition mode for quite some time," says Elinor Selame, president of BrandEquity International. "If we developed an inflexible branding system, they would just end up changing it over and over. They needed a very flexible, organic brand architecture that would grow with them."

BuildNet felt it couldn't just abruptly do away with the identities of its newly acquired companies. "It was crucial to our success that we maintain the equity each of these products had built in its specific marketplace," notes Bright. And the customers of the former companies needed to feel that BuildNet was not turning its back on them. So BrandEquity set out to develop a transitional branding system that would make the BuildNet identity most prominent, but visually integrate the identities of the sub-brands.

A Visual Umbrella

To achieve this, the BrandEquity team made subtle refinements to the original BuildNet logomark so that it forms a visual umbrella over the sub-brands. The original identity included a partially encircled "e" that looked similar to the trade dress used by IBM's E-Business. BrandEquity replaced the partial circle with an umbrella-like arc that is echoed in new logomarks for the acquired companies. To ensure that customers still recognized the products they had previously purchased from other companies, BrandEquity extracted simplified elements of their former identities and placed them under the graphic umbrella. Adding the tagline, "A BuildNet Solution" under each of the logos also helped unify the group.

[above] *As shown on the company letterhead, BrandEquity simplified the logo presentation to red, black, and white only, with the company names in black or white and their individual symbols and umbrellas in red. The typeface, a modified version of Gil Sans, had to work equally well in print, Web, and three-dimensional applications.*

Designers also changed the BuildNet typeface slightly, lightening it up by using a modified version of Gill Sans, a clean, highly legible face. "The typeface was very important, because it had to work for the Internet, print applications, signage, and other three-dimensional uses," notes Joseph Selame, BrandEquity's creative director on the project. They also simplified the logo presentation to red, black, and white only, with the company names in black or white and their individual symbols and umbrellas in red.

For BuildNet's crucial tradeshow launch, BrandEquity devised a color-coded system for signage, brochures, product information sheets, CD covers, and other collateral that would be passed out to attendees. In addition to the color coding, each product's collateral material was made distinct by watermark versions of their symbols used in the background.

A Living Identity

BuildNet's brand architecture continues to change with the company. A year after its initial spate of acquisitions, BuildNet launched the second phase of its identity program, moving away from the transitional, product-based identity to a monolithic system in which BuildNet is the flagbearer. The graphic elements from the sub-brands' former identities were replaced with the BuildNet "umbrella," signaling that all of their products are part of the BuildNet family.

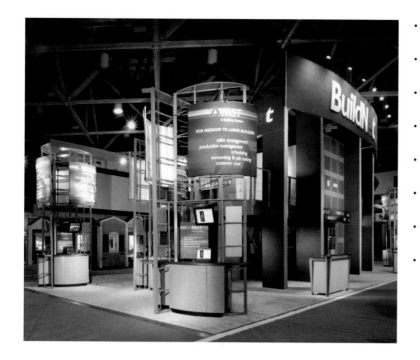

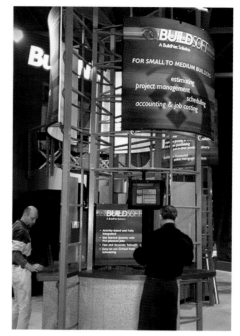

Bright says the "living" identity system has given BuildNet the flexibility to communicate with its market through all the changes the company has seen in its short history. "It has allowed us to clarify this really confusing process of going out and acquiring companies and products left and right," he explains. "The acquisitions could have caused a lot of confusion and concern, but we were able to show, in a graphic way, that all of our purchases fit into a logical process." A preliminary awareness report showed that the marketplace's recognition of the BuildNet brand increased dramatically since the new identity system was implemented.

As BuildNet makes new acquisitions, it evaluates the company's market strengths and brand equity to determine if a transitional identity should be used or whether the new company should be immediately enfolded within the monolithic identity. "We prefer to take them immediately to the monolithic style so that BuildNet's name dominates," notes Bright. "But with this system, we can fall back to a transitional identity if we feel a complete change would affect revenues, customers, or perceptions. This is not like removing a Band-Aid. Ripping it off really fast is not always the right answer." ∎

[opposite page] *To unify the BuildNet brand, while preserving the identities of its sub-brands, Brand Equity devised a color-coded system for brochures and other print collateral. Simplified graphics from their former identities are used as watermark-like elements in the new system.*

[above] *For BuildNet's crucial tradeshow launch in January 2000, its booth featured the BuildNet identity prominently. The subbrands were promoted at color-coded, circular kiosks.*

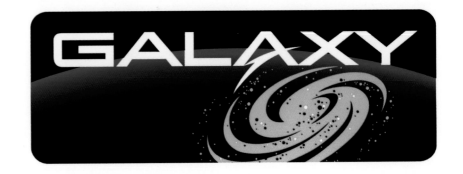

Galaxy Entertainment Inc.

A Toronto-based movie theater chain brands an out-of-this-world experience.

When your business is operating movie theaters, corporate identity is less about letterhead and logo design than it is about compelling environments and unique customer experiences. Entertainment value is the name of the game.

[above] *Shikatani Lacroix designed a logo that would translate well to a variety of applications, from paper products to exterior signage. The blue horizon behind the "swirling galaxy" suggests the beginning of a journey.*

[opposite page—top] *In the theater's lounge area, royalty-free photographs of outer space were enlarged and used as divider/backdrops. The theaters' public spaces are divided into "strike zones" that appeal to the different age groups patronizing the cineplex.*

[opposite page—bottom] *Type, colors, and lines lend a space-age aesthetic to Galaxy's stationery system. Designers were careful to stay away from cartoonish stereotypes about outer space.*

Galaxy Entertainment Inc. is one of a new breed of movie theater chains that won't settle for the vanilla-box megaplexes of the 1970s and 1980s. Instead, Galaxy is creating highly themed, immersive environments designed to inspire moviegoers to leave the couch and come to watch a movie on the big screen. "There has to be magic," says Ken Prue, Galaxy's vice president of marketing. "We have to create a stirring environment, and it has to be dramatically different from home, to get people to come."

Galaxy, owned by Canadian conglomerate Onex Corp., was established in 1998 with a unique positioning strategy: to build a chain of big-theater venues in Canadian communities with populations of between 75,000 and 100,000. The goal was to reinvigorate small and medium-sized communities with a multiplex theater experience normally associated with large urban markets such as Montreal and Toronto.

Getting the public to accept and buy into the new concept was a special concern. Galaxy knew it needed to create appealing destinations, but it also needed a strong identity and strategies that would allow it to create the theaters cost effectively. So the new company hired Shikatani Lacroix Design (Toronto) to help determine Galaxy's strategic direction and create an effective brand identity. Design work included a corporate mark, interior environments and fixtures, exterior facades, branding for transportation advertising, graphics and signage, corporate stationery, and packaging.

Big Bang

The core of Galaxy's corporate mission is encouraging moviegoers to experience the magic of movies, says Prue, and the company's name reflects that mission. The name was born when the company's leadership team was brainstorming ideas and someone described the thrill they felt during the opening scene of "Star Wars," when the words "Long ago, in a galaxy far, far away..." rolled onto the screen.

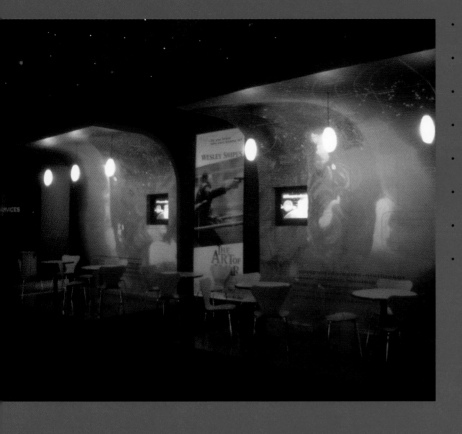

Client: Galaxy Entertainment Inc., Toronto

Ken Prue | vice president
| of marketing

Design Team: Shikatani Lacroix Design, Toronto

Jean Pierre Lacroix | president
Ed Shikatani | design director
Richard Dirstein | senior environmental
| graphic designer
Lynne Giles | senior graphic designer
Mark Willard | production designer
Murtuza Kitabi | production designer

"Galaxy means big. Galaxy means something exciting and mysterious, and galaxy means home," Prue notes. "It resonates on a lot of different levels." It was Shikatani Lacroix's job to take that concept and run with it, says Ed Shikatani, design director for the firm. "Some other movie chains had done a lot with concepts based on Hollywood or movie themes, but the galaxy concept provided a lot of room to grow."

Because Galaxy needed to keep ticket prices to a reasonable level in small communities where people generally have less disposable income, cost was a major consideration. "Cost effectiveness really drove our design, and the real challenge was creating a big impact using inexpensive materials in creative ways," says Shikatani.

Universal Mark

Shikatani Lacroix's primary concerns in developing the Galaxy logo were how it would translate to exterior signage and packaging, such as napkins, cups, and popcorn bags. Their solution was to depict a swirling galaxy that intersects with the second "a" in the Galaxy name. A blue horizon line behind the swirl suggests a view into outer space. "It

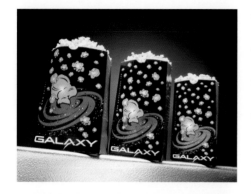

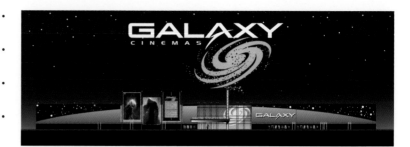

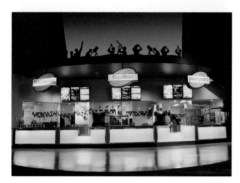

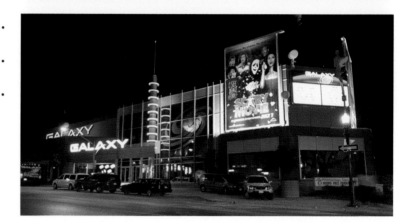

[top—left] *The new logo also adorns popcorn bags, napkins, and other paper items in the concession area.*

[bottom—left] *The theaters also include branded food outlets, much like food courts inside malls. Above this area, silhouette cut-outs depict stargazers. Using inexpensive materials and stagecraft techniques, Galaxy is able to create big-town movie venues in small towns of 75,000 to 100,000 people.*

[top—right] *Galaxy's bold exterior facade was designed to beckon moviegoers from afar. Often visible from nearby highways, it resembles a blue planet appearing on the horizon.*

[bottom—right] *In reality, the exterior is no less bold. A steel rail holding the illuminated logo connects to a tower with flashing neon rings, creating a distinct entrance. A huge, frosted-vinyl, galaxy-swirl graphic is visible from behind the theater's wall of glazing windows.*

signifies the beginning of a journey," notes Shikatani, "which is a kind of metaphor for the journey people take when they escape to a movie. It suggests infinite possibilities."

The mark needed to be kept simple for translation to signage. It also appears on print applications such as stationery, business cards, Galaxy VIP passes, and packaging, and makes a dramatic entrance statement on theater facades. From outside the theaters, the galaxy swirl also appears in a huge frosted-vinyl window graphic applied to a wall of glazing windows. Before opening a new theater in a community, Galaxy also wraps a public bus in the identity graphics.

Way-Out Environment

The design team's goal for the physical environment was to create an immersive experience that would inspire moviegoers to keep coming back for more. That meant building a space that is visually exciting and also changeable.

"People want to lose themselves in the movie experience," says Prue. "That's why they're willing to pay $10 or $12 to get into a movie theater. So we had to design elements that we could change easily to keep the space fresh and new for people who come frequently." To achieve this on Galaxy's modest budget, Shikatani Lacroix placed a lot of emphasis on lighting, using theatrical gels to change color and mood. Designers leveraged the theaters' 35-foot-high (10.7 meters), exposed ceilings by suspending huge dimensional icons, such as Saturn's rings and "clouds" of Lycra stretched over wire frames, from above. Space-themed photographic murals, produced from royalty-free images to cut costs, continue the space theme. Tickets are purchased from a box office that resembles a satellite. A hovering disk floats over the main concession stand, while cut-out figures of stargazers seem to be watching it.

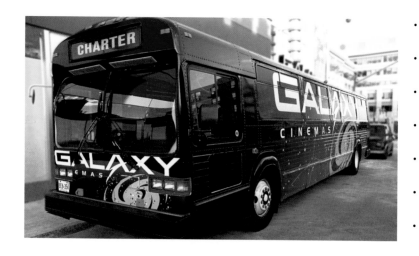

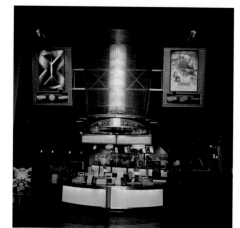

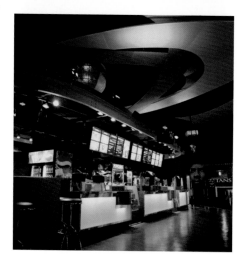

"We basically created a kit of parts that can be used in different ways depending on the actual site," explains Shikatani. "It's very modular to give Galaxy a lot of flexibility in building the environments."

To create areas that appeal to the vastly different age groups patronizing the theaters, the interior is divided into "strike zones" that include a series of branded food outlets, a cafe, and an interactive game area. Color blocking, audio zones, furniture, and lighting are used to define the spaces and encourage people to gather before and after movies. "We wanted to create experiences that would appeal to everyone, from the nineteen-year-olds that make up a large segment of our customer base to the forty-year-olds who are also an important target demographic," notes Prue.

The theater's bold, exterior facade beckons customers to a faraway place. Often visible from the highway, it is designed to resemble a nearby blue planet appearing over the horizon, on a field of black stars. A steel rail holding the logo sign connects to a tower with flashing neon rings, creating a distinct entrance. A huge galaxy swirl graphic is visible through the facade's front glazing windows. "We wanted it to be seen from far away and to really invite people in for a unique experience," Prue explains.

Box Office Hit

The first Galaxy theater opened in June 2000, and by spring of 2001, twelve theaters were in operation, with a total of eighty-eight screens. Ultimately, says Prue, the chain plans to roll out thirty theaters.

On average, attendance at the new Galaxy theaters is doubling or increasing, by two-and-a-half fold, the attendance at movies shown at other theaters in its communities. For example, at its theater in Peterborough, Ontario, which opened in July 2000, attendance was 230 percent of the attendance at two existing theaters in the community.

Prue attributes the success to a strong design concept. "Going to the movies is a highly discretionary experience. You don't have to go. So we need to create an environment that's so compelling you want to go there, and often. We believe we've achieved that." ∎

[above—top] *Moviegoers purchase tickets at box offices that resemble satellites. The space theme continues throughout the theaters, which average 40,000 square feet (3,721 square meters).*

[above—bottom] *Concessions, a major moneymaker in the theater business, were given dramatic treatments. Above the main popcorn stand, huge Saturn-like rings are suspended from the exposed ceiling.*

[left] *Just before a new theater opens, Galaxy wraps a local bus in the identity graphics. The Toronto-based company plans to open thirty theaters in smaller communities across Canada.*

TNT | Europe's leading express carrier brands a new era.

TNT has come a long way since its humble origins in 1946, when Australian Norm Thomas founded Thomas Nationwide Transport with one truck. The company has trekked the globe, moving its headquarters from Australia to Europe in 1992, when it combined operations with the postal groups of The Netherlands, Canada, France, Germany, and Sweden. In 1996, TNT was acquired by KPN, the Dutch postal/telecom group, and in 1998, the TNT Post Group (TPG) separated from KPN.

[above] *(Before) The boxy shape of TNT's former identity, which dated to 1948, was not perceived as modern or dynamic, and didn't reinforce the key attributes TNT wanted to communicate: globality, speed, and time. In addition, it had been applied inconsistently by operating units in various parts of the world.*

[opposite page] *(After) Flags bearing the new TNT identity fly over the company's headquarters in Amsterdam.*

By 1998, with operations in more than fifty countries, TNT was the largest express carrier in Europe and the third largest (in volume distribution) in the world, behind FedEx and UPS. But through the years, ownership transitions and the proliferation of separate business units resulted in an extremely fragmented identity. TNT's identity was not only outdated (it could be traced to 1948), but had been diluted by inconsistent use across geographic and product boundaries.

"Very simply, we were not exploiting the benefits of uniform and consistent monolithic branding," says Mathieu Lorjé, director of corporate communication for TNT. "It was more than time for an update."

TNT enlisted BrownKSDP (Amsterdam) to develop a new global identity that would reflect the positioning and ambitions of the newly integrated company while leveraging the positive attributes of the TNT brand.

Client: TNT, Amsterdam

| Peter van Minderhout | vice president of corporate communication and human resources |
| Mathieu Lorjé | director corporate communication |

Design Team: BrownKSDP, Amsterdam

Joe Kieser	ceo
Kees Schilperoort	group design director
Nikki Constantine	senior consultant
Josephine Nandan	consultant
Michael King	design director/senior designer
Adrian van Wyk	graphic designer
John Comitis	graphic designer
Dante Lupini	senior industrial designer
Sam Charlier	senior architectural and environmental designer
Wayne Smith	design technician

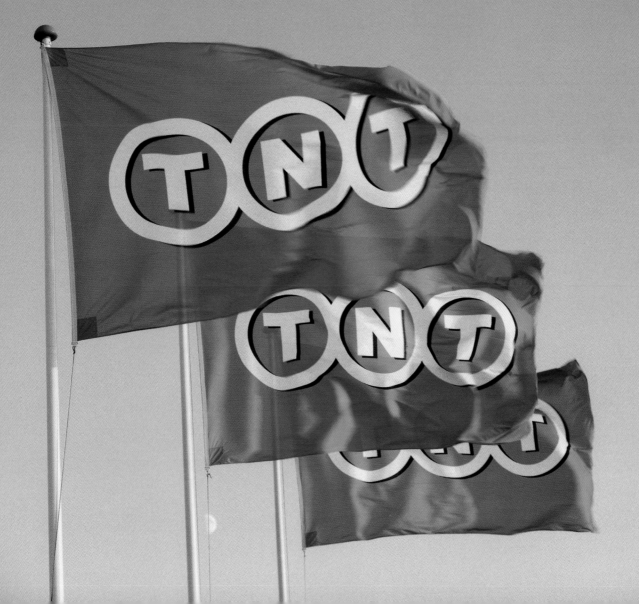

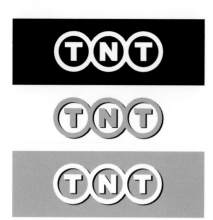

[above] (After) TNT's new logomark uses the purest of forms, the circle, to make a strong, modern statement and transcend cultural barriers. It also alludes to the shape of clocks and the globe, reinforcing the importance of time and TNT's global reach. The use of orange links the mark to TNT's former identity.

[opposite page—top] TNT owns and operates more than 22,000 vehicles worldwide, and re-dressing them with the new identity was a major part of the rollout. To centralize the job, BrownKSDP prepared a detailed livery manual, and with another local firm, audited TNT's worldwide fleet. Specific templates were then created for each vehicle type and shipped to individual locations.

In addition to creating a stand-alone, monolithic brand, says Lorje, TNT also hoped the new identity would be a catalyst for unifying its 67,000 employees worldwide. "We saw it as an opportunity to signal to our own people that there were serious issues to be solved and that management was committed to renewing the company and investing in its future development."

Fast Tracking

Given TNT's business focus, it was perhaps fitting that the identity development was on an extremely fast-track schedule. BrownKSDP was briefed on the project in September 1997, and the launch scheduled for April 1998.

The design consultancy used a unique process to expedite the rebranding. First they identified the TNT brand's key positive attributes, including color, type, visual language, and graphic devices. Then each element was isolated and taken through a series of modifications, ranging from slight changes (evolutionary) to more radical revisions (revolutionary). "This process is very effective under tight deadlines, as you can develop a wide range of permutations in a short period of time," explains Michael King, KSDP's design director. "It also allows you to pinpoint distinct landmarks and transfer them to the evolved brand." The team was able to quickly generate 250 brand permutations. These were filtered, refined, and narrowed to five options to present to the TNT management board.

Full Circle

From the outset, King and his team recognized that the new identity would be evolutionary rather than revolutionary. "There was a lot of heritage attached to the brand, and we wanted to ensure we preserved all the equities we could." Furthermore, he notes, launching a new global identity from scratch can often be a prohibitively expensive proposition, and a risky one. "A radically new identity would require a massive communications budget behind it. We knew a large portion of the TNT budget was going to updating its livery," he explains. And often, he adds, companies that stray too far from their former identities risk alienating their customer base.

Based on research and meetings with the TNT management team, BrownKSDP also knew the new identity should express the key brand attributes of speed, global reach, motion, and time. It also needed to subtly reinforce TNT's business diversity (express, logistics, and mail) and its advanced technology (it boasts the most sophisticated information technology systems in the industry).

TNT's old identity was considered too rigid and static for a company whose livelihood depends on speed and rapid response to client needs. Its rectangular, box-shaped logo was not perceived as being modern or dynamic. The company's historic use of orange, however, was an equity that needed to be retained, says King.

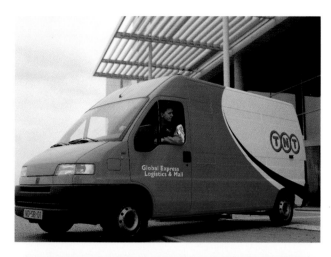

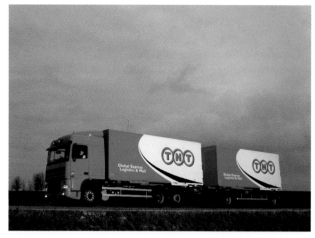

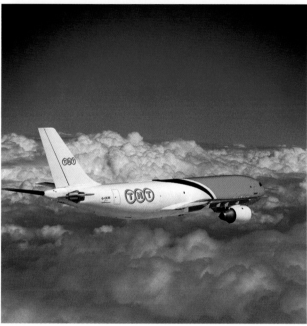

BrownKSDP's final solution evolves from the old TNT mark with the purest of forms—circles surrounding the three letters in the company name. Strong and graphic, circles can translate across many cultures, says King, and their reference to the shape of clocks, tires, and the globe reinforces the importance of time. "Using this pure and most organic of forms meant that we could cross over multiple cultural issues and not have to rely on a huge communications budget to reinforce the identity," King explains. Designers brightened the existing "industrial" orange and added black as an accent color. To add depth and reinforce the idea of movement, they added a drop shadow to the mark. The tagline "Global express, logistics and mail" articulates the brand offering.

BrownKSDP paired the interlinking-circles logotype with a graphic element they call the "dynamic ellipse," a swoosh-like device featured on packaging, vehicles, and uniforms to create an impression of speed and movement through space. On express letter packaging, they incorporated dynamic sporting images to express the attributes of speed, focus, and achieving a goal. "The universal associations attached to sport allow the packaging to communicate across cultural barriers," King notes.

[bottom—left] *TNT also operates sixty-one aircraft, which received new graphics based on BrownKSDP's detailed livery manual.*

[bottom—right] *At first glance, TNT packaging reads as primarily orange, a perception TNT reinforced by floodcoating many packaging elements in the newly refined color. "Especially in the beginning of the rollout, we wanted to quickly and firmly establish TNT's ownership of the orange," notes Michael King, BrownKSDP's design director.*

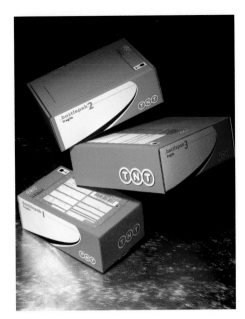

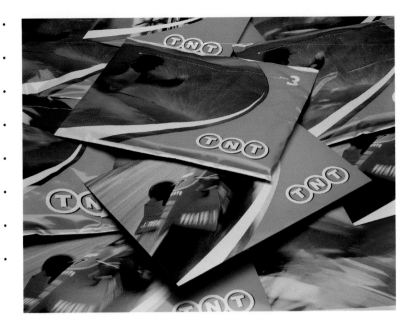

Global Reach

Because TNT operates in more than 200 countries, its new identity literally spans the globe. The new program extends to 1,300 offices and depots worldwide, as well as to 22,000 vehicles and sixty-one aircraft.

TNT's initial launch of the new identity targeted its five major markets: The Netherlands, Italy, Australia, the United Kingdom, and Germany. After a public launch on April 27, 1998, at its new European air hub in Liege, Belgium, TNT implemented the phase-one rollout in three months, then tackled an additional twenty-five countries during the remainder of 1998. In 1999, the identity was rolled out to the other 170 countries where TNT does business.

[above left] *BrownKSDP expanded TNT's graphic vocabulary with an element called the "dynamic ellipse," which is featured on the sides of packaging, uniforms, and vehicles to create an impression of speed and movement through space.*

[above right] *Express packaging features dynamic sporting images that convey the idea of speed, focus, and achieving a goal. "The universal associations attached to sport allow the packaging to cross cultural barriers," notes design director Michael King.*

[right] *With operations in 200 countries, TNT operates 1,300 offices and depots, all of which received new signage as part of the identity update.*

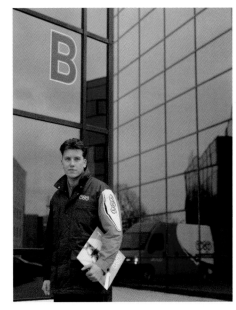

To make the aggressive rollout possible, BrownKSDP supplied all artwork (including the logo, core stationery, livery guidelines, and communications collateral) to TNT digitally. TNT then coordinated the rollout centrally, outsourcing various elements to vendors who shipped the finished products to Amsterdam. All packaging, signage, uniforms, business collateral, and other materials were shipped from Amsterdam to individual locations.

To re-dress company vehicles, BrownKSDP developed a detailed livery manual, and working with another local firm, audited TNT's worldwide fleet and developed graphic templates specific to each vehicle type. At the peak of the rollout, says Lorjé, twenty-three TNT employees, including four controllers, were solely dedicated to the operational aspects of the implementation.

Global Success

TNT's business grew 25 percent in 2000, following a 12 percent increase in 1999. "To what extent has the new corporate identity contributed to that?" asks Lorjé. "It's difficult to say."

But research conducted by TNT shows that the new identity has affected the company's success in ways other than financial. Brand tracking research showed that customer satisfaction, already high before the new identity, has increased 10 percent since the rollout. And a study of "internal motivation" showed that employees are feeling more positive about their company. "They can see now the global character, the diversity of business, and the commitment our board of management has made to investing in the future," Lorjé explains. "We have a better story now to tell our customers, and it translates into a good feeling about our own jobs." ∎

[above left] *The new branding was also extended to third-party products and elements. While they are branded with core TNT visual elements (logo, color, and forms), the brand extension allows the products' unique visual languages to dominate.*

[above right] *The identity program also encompassed a new workwear system that features the logomark and the dynamic ellipse.*

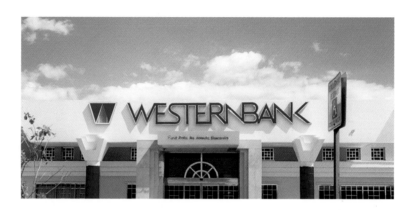

Westernbank

Establishing its first urban branch, a Puerto Rican bank polishes its corporate image.

Puerto Rico's third largest bank has a gold-plated financial standing, ranking number one among 10,000 U.S. banks in return on equity. In operation for more than forty-three years without ever experiencing an annual loss, Westernbank is known for its sound financial management and its integrity.

[above] *(Before) Westernbank's old logo used a blocky, 1970s-era typeface that needed modernizing.*

[opposite page—top] *(After) The new logo uses Waters Titling, an elegant but classic typeface designers felt could bridge the gap between Old World tradition and modern-day sophistication. A redrawn coat of arms and the tagline "El Banco del Pueblo" (The Bank of the People) are used in formal communications.*

[opposite page—bottom] *Westernbank's coat of arms, a traditional symbol for European banks, appears on teller blazers and on formal communications, such as stationery.*

But customers don't choose banks based on their financial statements, and Westernbank's nondescript identity and branch environments weren't on par with its world-class operation. Poised to expand into the metropolitan San Juan market, Westernbank knew it needed to create a world-class identity and a dynamic, technologically integrated, and customer-friendly branch environment to attract new banking customers.

Friendly, But Professional

Westernbank had long called itself "El Banco del Pueblo" (the Bank of the People), and wanted to maintain its equity in this customer-friendly identity. But it also wanted to present a polished image to San Juan's more sophisticated population. And CEO Frank Stipes recognized the need to standardize Westernbank's identity from branch to branch to improve brand awareness.

WESTERNBANK

El Banco del Pueblo

Client: Westernbank, Mayaguez, Puerto Rico

Frank C. Stipes | president/chairman/CEO

Design Team: BachmanMiller Group, Dublin, Ohio

Tim Bachman	account executive
Deb Miller	creative director
Dale Rose	planner/designer/project manager
Bonnie Lattimer	graphic designer/art director
Rebecca Kenneweg	resource director/colorist
Tim John	multimedia designer/illustrator
Stephanie Romo	multimedia designer
Jeffrey Bump	multimedia designer/3D animator
Sam Fung	designer/retail environment
Nan McHugh	resource assistant
Sally Matthews	technical documentation
Robert Aybar-Imbert	architect (Puerto Rico)

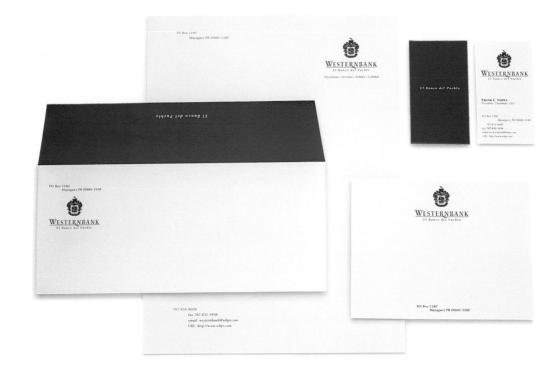

[above] *The stationery system is suitably conservative for a bank, incorporating Westernbank's coat of arms and the logo in navy and red.*

"Our financials were extraordinary, but our presentation was disastrous," Stipes notes. "We looked like just another bank, not the star player we are." So Stipes chose the BachmanMiller Group (Dublin, Ohio) to refine the bank's identity and design the interiors of its new San Juan branch. He wanted to keep the bank's existing coat of arms (a traditional symbol among European banks) for more formal applications, such as stationery, teller blazers, and flags, but was looking for a modern, energetic look for signage, branch interiors, and other applications.

Old World Meets the New

BachmanMiller started by redrawing the coat of arms, sharpening its lines for a clean, crisper look that reproduces well on letterhead and business cards. Then they tackled the Westernbank logo. "We knew it had to be a bridge between the Old World heritage of the banking industry and the modern, sophisticated image Westernbank was looking for," says Bonnie Lattimer, BachmanMiller's art director for the project. "It also had to be flexible, because they wanted the bank environment to be very contemporary."

Lattimer replaced the blocky, 1970s-era lettering on the Westernbank logo with Waters Titling, an elegant serif face. "It's a timeless typeface that's not too plain, but not too ornate," says Dale Rose, BachmanMiller Group's project manager. "And most important, it set Westernbank apart from its competitors." The typeface's "R" includes a unique scrolling descender and it also contains a distinctive "W," which designers eventually reproduced as door handles on the new branch bank.

[left & below] *BachmanMiller Group also helped Westernbank develop sub-brands for products such as its juvenile savings accounts.*

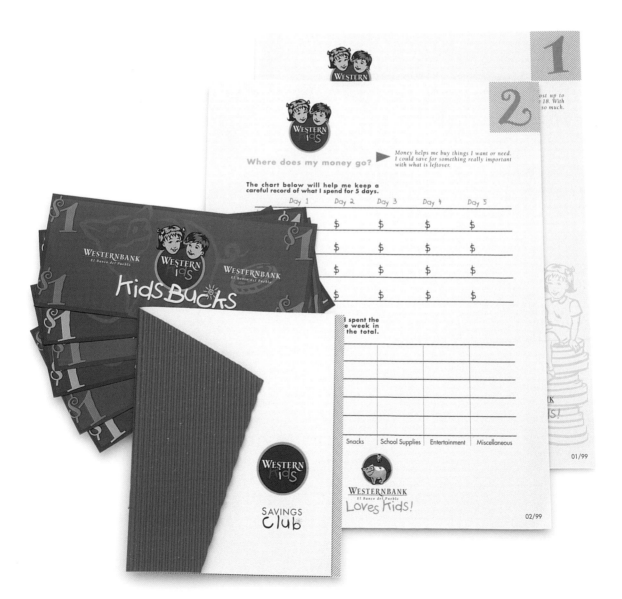

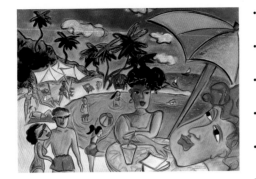

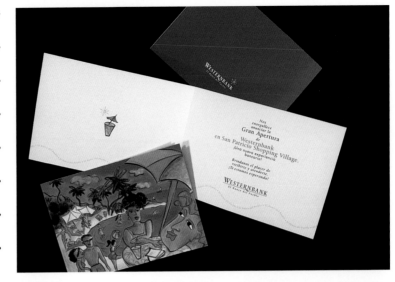

[above] *As part of the brand development, Westernbank commissioned original illustrations depicting Puerto Rican life that visually support its "El Banco del Pueblo" tagline. The illustrations, including a beach scene, children playing in a park, and a cafe scene set in Old San Juan, were reproduced in graphics, murals, banners, and branch interiors. (Illustrations by Tatjana Krizmanic, Boulder, Colorado)*

[right] *Grand opening invitations featured the colorful illustrations commissioned for the project. At the opening event, the bank gave away frameable prints of the illustrations encased in a specially designed folder.*

An Engaging Environment

Bank interiors were a crucial identity statement for Westernbank, and BachmanMiller knew the environment had to be not only elegant, but dynamic and fun. For the sake of continuity, they decided to stay with the red, yellow, and blue color palette Westernbank had been using in recently constructed branches. But they added natural birch finishes, yellow porcelain tile flooring, and blue pearl granite countertops to create an ambiance that is, in Rose's words, "elegant but friendly, professional but not stodgy." To further articulate the brand, Westernbank commissioned a series of illustrations that depict Puerto Rican life, from the beach to Old San Juan. The illustrations are reproduced in graphics, murals, banners, and branch interiors.

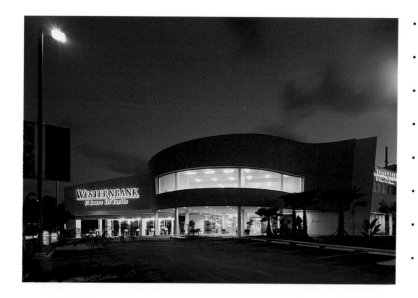

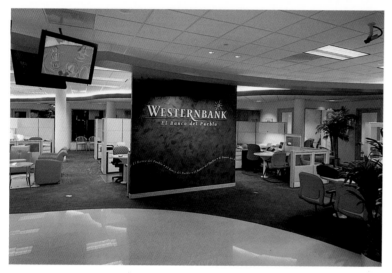

[left—top] *Westernbank's new identity translates well to signage on the exterior of the new San Juan branch. Signs at all thirty-six branch locations have been converted to the new identity.*

[left—bottom] *The "logo wall" just inside the San Juan branch treats the logo playfully, pairing it with a whimsical sun graphic and a rolling, wavelike line of type below that repeats the tagline. The sun graphic is often used as an informal addition to the logo.*

Stipes insisted the branch locations be customer-friendly, transaction-oriented, and pulsing with energy. Service features include valet parking and special monitors that allow tellers to view drive-through customers without turning their backs on customers inside the bank. BachmanMiller incorporated movement and interactivity as much as possible. Tiny customer monitors at the teller windows, for example, show videos promoting Westernbank products. Touchscreen trivia games entertain children and adults while they wait, and rotating banners and an image projector add to the energy level.

Stipes says the new identity and avant garde branch design have been very well received in Puerto Rico. "The look is very strong and very elegant, but not intimidating, which is just the message we wanted to send," notes Stipes. "It has made everyone realize that Westernbank is the most prestigious bank on the island, if not the oldest or the biggest." ∎

Directory

A

Addis | PG 61
2515 Ninth St.
Berkeley, CA 94710
Steve Addis, chairman
510-704-7500
fax: 510-704-7501
www.addis.com

Addwater | PG 115
580 Howard St., Suite 102
San Francisco, CA 94105
Rob Gemmell, principal
415-982-8344
fax: 415-982-8348
www.addwater.com

Primo Angeli | PG 17
101 15th St.
San Francisco, CA 94103
Jim Goodell, principal
415-551-1900
fax: 415-551-1919
www.primo.com

B

BachmanMiller Group | PG 153
6001 Memorial Drive
Dublin, OH 43017
Tim Bachman, principal
614-793-9993
fax: 614-793-1607
www.bachmanmiller.com

BrandEquity International | PG 137
2330 Washington St.
Newton, MA 02462
Elinor Selame, president
617-969-3150
fax: 617-969-1944
www.brandequity.com

BrownKSDP | PG 147
Sarphatikade 10
1017 WV Amsterdam
The Netherlands
Michael King, design director
31-20-530-8000
fax: 31-20-530-8035
www.brownksdp.com

C

Carbone Smolan Agency | PG 109
22 West 19th St., 10th Floor
New York, NY 10011
Ken Carbone, executive creative director
212-807-0011
fax: 212-807-0870
www.carbonesmolan.com

G

Girvin | PG 79
1601 Second Ave.
The Fifth Floor
Seattle, WA 98101
Ann Bradford, director of strategic
branding and marketing
206-674-7808
fax: 206-674-7909
www.girvin.com

Malcolm Grear Designers Inc. | PG 73
391-393 Eddy St.
Providence, RI 02903
Joel Grear, executive vice president
401-331-2891
fax: 401-331-0230
www.mgrear.com

I

Interbrand | PG 43
200 E. Randolph St., Suite 3500
Chicago, IL 60601
Kris Larsen, managing director
312-240-9700
fax: 312-240-9701
www.interbrand.com

Alexander Isley Inc. | PG 49
4 Old Mill Rd.
Redding, CT 06896
Alexander Isley, principal
203-544-9692;
fax: 203-544-7189
www.alexanderisley.com

K

Karo (Toronto) Inc. | PG 123
10 Price St.
Toronto, Ontario
Canada M4W 1Z4
Paul Browning, executive vice president
416-927-7094
fax: 416-928-6713
www.karoinc.com

L

Landor Associates | PG 87
Klamath House
1001 Front St.
San Francisco, CA 94111
Margaret Youngblood, creative director
for corporate identity
415-365-3190
fax: 415-365-1700
www.landor.com

Landor Associates | PG 129
44, rue des petites écuries
75010 Paris
France
Aaron Levin, creative director
33 (0) 1 53 34 31 00
fax: 33 (0) 1 53 34 31 01
www.landor.com

The Leonhardt Group | PG 55
1218 Third Ave., Suite 620
Seattle, WA 98101
206-624-0551
fax: 206-624-0875
www.tlg.com

Lippincott & Margulies | PG 67
499 Park Ave.
New York, NY 10022
Brendán Murphy, partner/design director
212-521-0000
fax: 212-308-8952
www.lippincott-margulies.com

M

The McCulley Group | PG 29
415 South Cedros Ave., Studio 240
Solana Beach, CA 92075
John Riley McCulley, principal
858-259-5222
fax: 858-259-1877
www.mcculleygroup.com

O

Kiku Obata & Company | PG 11
6161 Delmar Blvd., Suite 200
St. Louis, MO 63112
Kiku Obata, principal
314-361-3110
fax: 314-361-4716
www.kikuobata.com

P

Pentagram Design Inc. | PG 95
387 Tehama St.
San Francisco, CA 94103
Kit Hinrichs, principal/creative director
415-896-0499
fax: 415-538-1930
www.pentagram.com

S

Sayles Graphic Design | PG 35
3701 Beaver Ave.
Des Moines, IA 50310
John Sayles, principal
515-279-2922
fax: 515-279-0212
www.saylesdesign.com

Shikatani Lacroix Design | PG 143
387 Richmond St., East
Toronto, Ontario
Canada M5A 1P6
Ed Shikatani, design director
416-367-1999
fax: 416-367-5451
www.sld.com

T

Tharp Did It | PG 23
50 University Ave., Suite 23
Los Gatos, CA 95030
408-354-6726
fax: 408-354-1450
www.tharpdidit.com

W

Wolff Olins | PG 103
10 Regents Wharf
All Saints Street
London NI 9RL
UK
Nigel Markwick, senior brand consultant
44 (0) 20 7713 7733
fax: 44 (0) 20 7713 0217
www.wolff-olins.com

About the Author

Pat Matson Knapp is a Cincinnati-based writer and editor whose work focuses on design and its effects on business. A former newspaper journalist, she was editor of *IDENTITY*, a magazine devoted to corporate identity and environmental graphics, and was managing editor of *VM+SD* (Visual Merchandising and Store Design) magazine. She has contributed to a wide range of design publications. ∎